IMAGES
of America

SARASOTA

IMAGES
of America

SARASOTA

Amy A. Elder

ARCADIA

Published by Arcadia Publishing
an imprint of Tempus Publishing Inc.
Charleston SC, Chicago, Portsmouth NH, San Francisco

Printed in Great Britain

Library of Congress Catalog Card Number: 2003106551

For all general information contact Arcadia Publishing at:
Telephone 843-853-2070
Fax 843-853-0044
E-mail sales@arcadiapublishing.com
For customer service and orders:
Toll-Free 1-888-313-2665

Visit us on the internet at http://www.arcadiapublishing.com

This book is dedicated to Beverly Arnold Stephansen.

CONTENTS

ACKNOWLEDGMENTS

Without the help of Ann Shank, Mark Smith, and Dan Hughes from the Sarasota History Center; Scott Stroh III and Diane Gootee from Historic Spanish Point; Heidi Taylor from the John and Mable Ringling Museum of Art; and Dorothy Korwek from the Venice Archives and Area Historical Collection, this book would not have been possible. Thank you all.

I would like to thank my editors from Arcadia Publishing; my proof-readers: Edie Smith, Betsy Elder, and David Keane; the following authors for their guidance: Linda Trice and Frank Remkiewicz; the following friends for their support: Sylvia Nissley, Ruth Wishengrad, and Carolyn Reed; my mentor Jean Elder who's three favorite words were, "Research, Research, Research;" and finally, someone I greatly admire for her talent and promotion of the arts, Betty Altman, past president and member of the National League of American Pen Women, Sarasota Branch.

A big thank you goes to the Sarasota residents who have donated photographs to the Sarasota History Center, especially Pete Esthus and the late Lillian Burns. You have made it possible to keep Sarasota's history alive for future generations.

INTRODUCTION

Sarasota has a long and varied past. Originally part of Manatee County, Sarasota County actually wasn't separated until 1921. As the early settlers divided their homesteads from the vast tracts of unclaimed land on the bay front, the barrier islands, and the mainland, as well as inland portions, they began to assign names to the areas. Names we are now familiar with are often little more than 100 years old. Names such as Siesta, Longboat, Bee Ridge, and Fruitville, now key areas of the city of Sarasota, were rough designations of areas, often agricultural zones more than communities.

Starting with rural agrarian settlers, Sarasota County has a long tradition of self-made individuals, entrepreneurs who took a setting of natural beauty and plenty and reshaped it in many ways to provide what is today a thriving city. This new settlement, nestled into the beautiful islands and bays that once attracted ancient people 4,000 years ago and the explorer Hernando de Soto in 1539, also attracted many others to this area.

As Sarasota developed, it went through many phases. From a period of settlement—marred by the second and third Seminole Wars—it entered a frontier period, reminiscent of the Wild West. Many people would be surprised to learn that early in Sarasota history, there were periods of widespread lawlessness, from the early homestead burnings by Holata Micco (also known as Billy Bowlegs) during the Seminole Wars, to the vigilante murders of "Tip" Riley, and the postmaster, Charles Abbe. A later murder of developer Harry Higel was never solved.

Soon, the Florida Mortgage and Insurance Development Company began promoting Sarasota in Scotland, and Col. J. Hamilton Gillespie was hired to manage the development. He was responsible for large-scale platting of streets and building hotels, housing, and businesses, which started the city of Sarasota.

With more and more residents, city water and sewer soon followed. The buildings first erected were replaced, sometimes after major fires, leading to the development of a fire company. This cycle of building and rebuilding continues today, much to the chagrin of some residents who bemoan the loss of history from demolishing classic and historic structures.

One

OSPREY

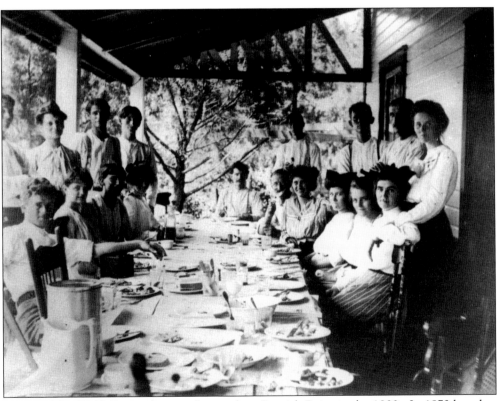

Guests of the Webb Resort dine on the porch at Spanish Point in the 1800s. In 1872 boarders paid $10 a week for room and board. Northerners would come and stay at the resort—many due to poor health—along with sport fisherman and hunters. The water was abundant with fish and the woods were full of wild game.

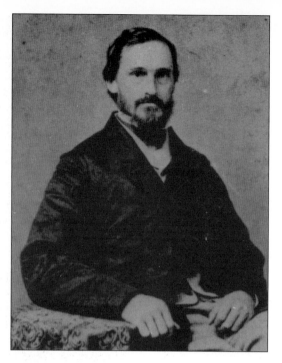

Shown in this *c.* 1880s image is John Greene Webb, who brought his family to Osprey in 1867. He worked hard to clear the land and build a home and garden where he grew sugar cane and other vegetables. He was a capable man who farmed, fished, and took in boarders. He was fascinated with the Indian middens on the property, so he sent artifacts and Indian specimens to the Smithsonian Institute. During the time that he lived in Spanish Point, several scientists came to visit and do research. They collected specimens including shells and mollusks. When his wife died in 1884 he married her sister Emily. He is buried between his two wives at Spanish Point.

Eliza Ophelia Groves Webb, pictured in the 1880s, married husband John on Christmas Eve in 1845. They had five children: Anna, William, John Walter (Jack), Virginia, and Eliza (Lizzie). Because of Eliza's asthma, she wanted to move somewhere warmer than New York. She hoped to move to Virginia where the family had visited and met some dear friends. However, when the Civil War broke out, they decided to wait. In the meantime they heard of the Homestead Act of 1862 in Florida, and they moved there instead. She and her five children worked together to keep the property running by helping with the farming, cooking, and cleaning. Later, when they started taking in boarders for the winter season, she ran the house. Her lifestyle changed when they moved to rural Florida. They could no longer buy supplies as readily, so they made due by collecting and eating turtle eggs, mullet, oysters, and vegetables. They used bark to dye their clothes and hunted for turkey and deer. Eliza died in 1884, allegedly, by helping to put out a fire, which inflamed her asthma and led to her death.

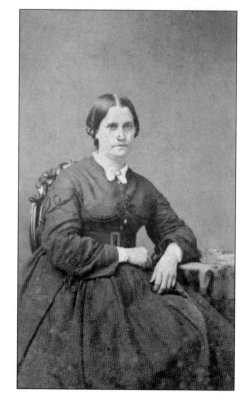

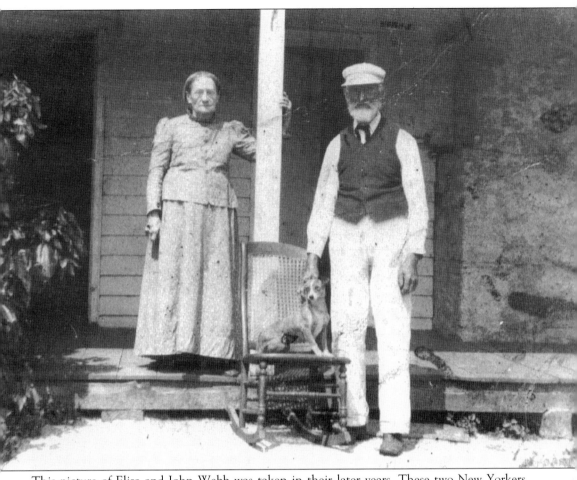

This picture of Eliza and John Webb was taken in their later years. These two New Yorkers successfully homesteaded and lived in Florida for several years. They braved and adapted to pioneer living in Sarasota County.

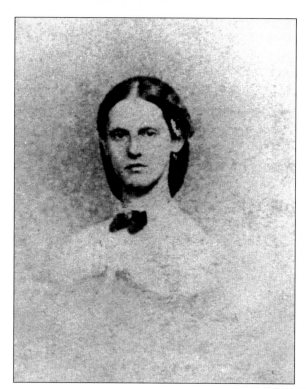

Anna Z. Webb, the oldest of five children, was 20 when she left for Florida. She liked to sketch her environment in a sketchpad and found many things to draw on the trip south, as well as at her new home at Spanish Point. She married a Confederate cavalry officer named Robert Stewart Griffith at Spanish Point and within a year they moved north to Snead Island to build a house and start a family. Robert Griffith became a clerk in Manatee County.

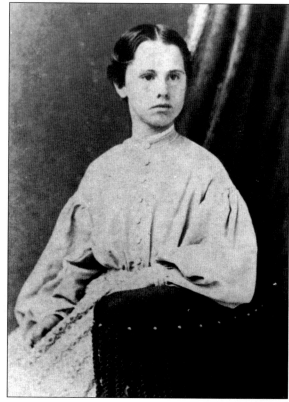

Virginia Brent Webb, known as Ginny, was only 7 when her family moved to Florida. She married Frank Guptill at age 17; she died at 18 after a fall that induced labor, during which she and her baby died.

John Walter Webb, known as Jack, was 8 when the family moved to Florida. He was the second son and built the white cottage now known as "the dormitory" for his wife.

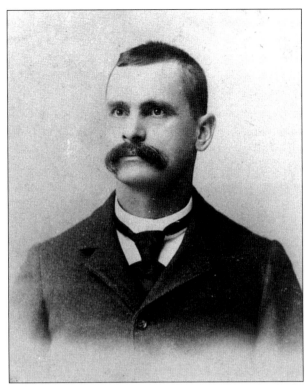

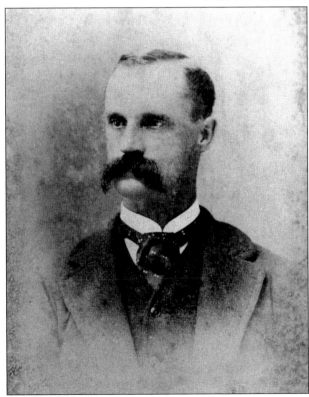

Will (or Willie) Webb was 17 when they left for Florida. He worked with Frank Guptill building boats, and he sailed the family's fresh produce to Key West on the schooner *The Ruby*.

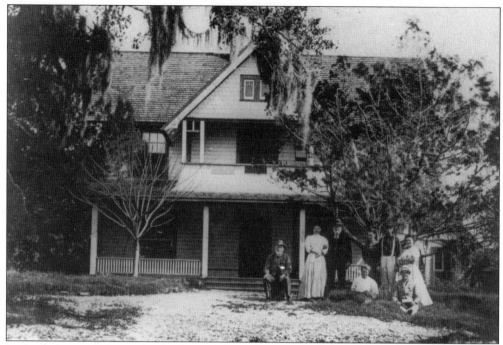

Frank Guptill built his house on an ancient Indian midden, named Archaic Midden, which is the oldest one on the property. A fresh water spring exists there, which was necessary for the homestead because they were surrounded by salt water. Eliza Webb, known as Lizzie, is shown in a 1910 photograph, on the back row, right, standing next to husband Frank Guptill. She was 11 when she moved to Florida, and she married Frank Guptill after her sister Ginny left him a widower.

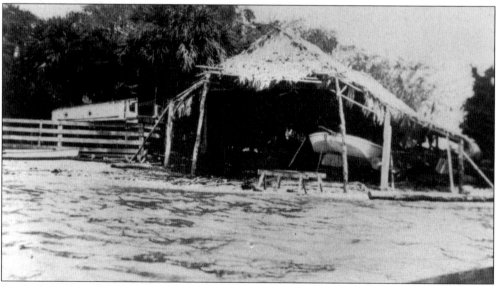

Frank Guptill was known as one of the best boat builders in the area. He built several boats, including a 12-ton sharpie called *The Florence*, named after his niece. Lizzie and Frank lived on the boat while their house was being built. This is a picture taken in the 1880s of Frank Guptill's boathouse.

The packinghouse was built after the Webbs lost their first crop because they were unable to get the produce to market in time. They also experienced a frost the first winter, which killed many of their plants, including the sugar cane and some fruit trees. As citrus farmers they learned the hard way that packaging fruit with Spanish moss was not a good idea. They tried this method and discovered the moss was full of bugs, which ate the fruit. The packinghouse had an orange grader that divided the oranges by size. By 1884 the Webbs were shipping 30 thousand oranges a year.

Fiddler footbridge was the original bridge built by the Webbs. Guptill house is seen under construction in the background. This 1901 picture was taken from the roof of the white cottage known as "the dormitory," which housed the spillover guests.

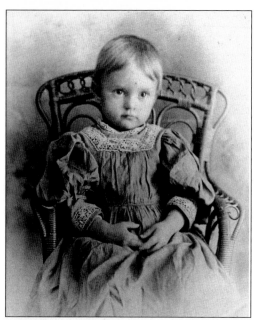

Mabel Webb was the daughter of Will and Marge Webb. She was born the day Mary's Chapel was completed; she was married at Mary's Chapel and was given special permission to be buried there.

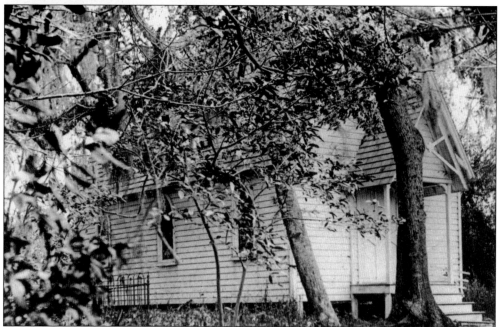

Mary's Chapel was built under shady trees at Spanish Point. The chapel was built in honor of winter guest Mary Sherrill, who died of tuberculosis while she was staying at the Webb Resort. Her parents and friends provided money for a memorial church to be built in her name. William Dutton, a long time boarder of Spanish Point, designed the church. Will Webb built the church next to his sister Virginia's and mother's graves. Mary's church in Louisville, Kentucky donated two stained-glass windows. The Sherrill family donated an organ, and Mary's classmates from the New England Conservatory of Music donated a bell. The quaint church became the focal point of the community, and many weddings and services were held here. The cost of the church was $441 to build and $224 to furnish.

Mary Sherrill came to Spanish Point in 1892 with her mother from their home in Louisville, Kentucky. Mary was suffering from tuberculosis and died five weeks after her arrival. During the time she was here she enjoyed strolling through Spanish Point and reading under the oak trees. In her memory, a chapel was erected in her name and located where she liked to read.

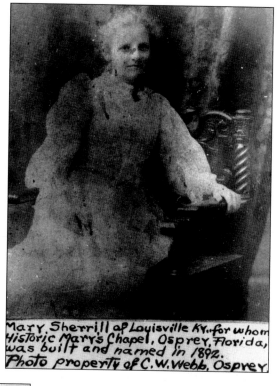

This hotel registry shows that Mary Sherrill and her mother stayed at the Webb's Resort at Spanish Point in 1892.

17

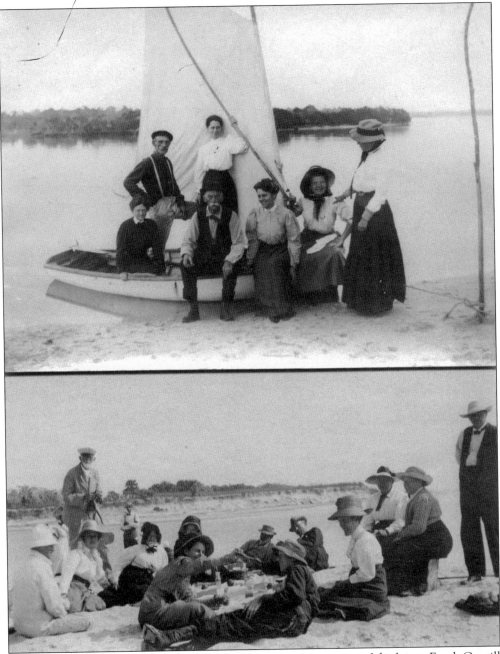

The top photograph shows guests of the Webb Resort enjoying one of the boats. Frank Guptill is in white suspenders with his wife in white beside him. The bottom picture shows guests relaxing on the beach at Webb's Resort.

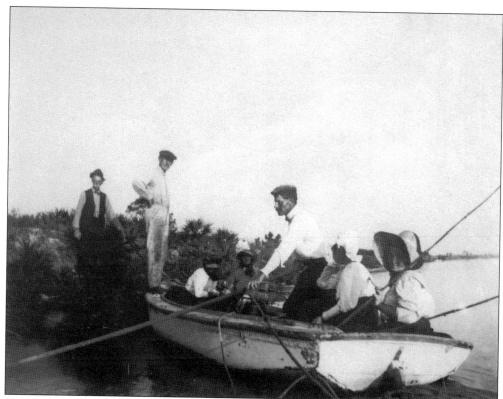

Guests enjoyed taking boating and fishing trips around the area in 1905. They were able to view the water from the boats rather than try to look through the thick hammock of palmettos and shrubs.

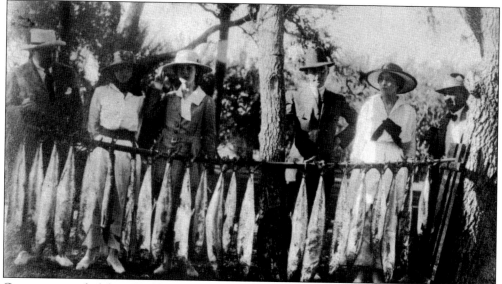

Guests pose with fish at Webb's Resort. The early photographs show that fish were abundant in the local waters. Stories have been told that fish were so numerous that they would jump into your boat as you rowed across the bay.

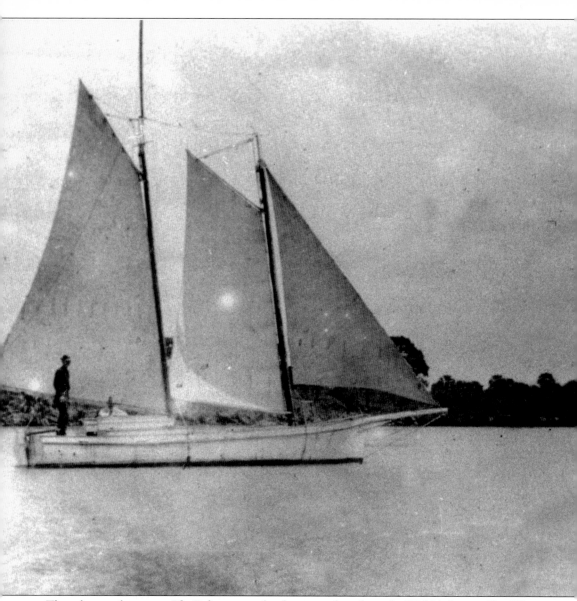

The schooner known as *The Ruby* was used to bring produce from the Webb's farm to Key West and Cedar Key. The schooner transported vegetables, sugar cane, and oranges. The Webbs used the money from their boarders to buy this five-ton vessel. They found the vessel in Manatee and refit her to carry their produce.

The Magic was the name of the boat that transported the Webbs around the local waters. The Webb children particularly enjoyed the use of this boat when visiting neighbors, since there were few roads and long distances overland between homesteads.

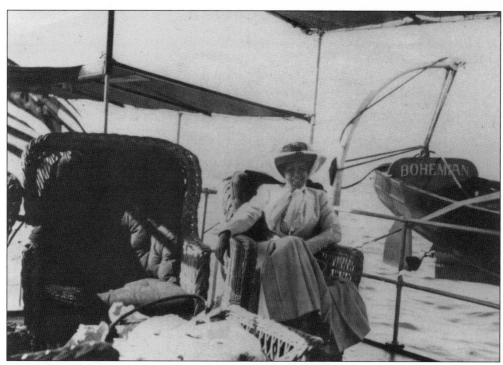

A guest is seen enjoying a cruise on Mrs. Potter Palmer's yacht at Spanish Point in 1910.

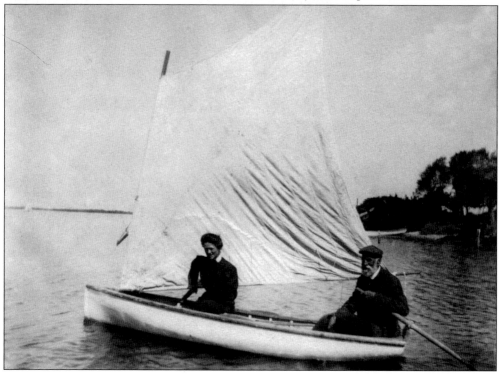

The man and women are guests of Webb's Resort. Boating on Little Sarasota Bay was a popular pastime for guests.

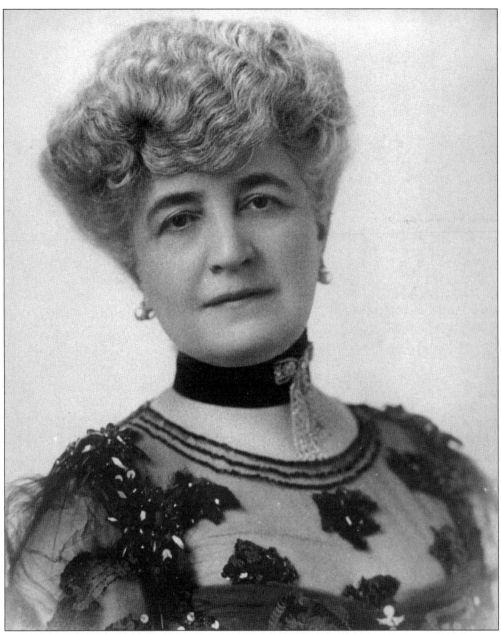

This classic portrait of Mrs. Potter Palmer dates from 1912. She was born Bertha Mathilde Honore on May 22, 1849 in Louisville, Kentucky, and died on May 5, 1918 at Osprey Point. She had hoped to live into her 90s like her father; however, she died of breast cancer just before she turned 69. She married Potter Palmer of Chicago in 1870 and had two sons, Honore and Potter Jr. Her sister Ida married Fredrick Dent Grant, oldest son of Ulysses S. Grant. Mrs. Palmer became a leading developer and experimental agriculturist in Sarasota County. She worked hard to be a role model to women. Although Bertha traveled extensively to Paris and Chicago, she still directed the daily agricultural operations of all her property. She insisted her manager report hourly on work that was being done on the properties. Bertha lived in Sarasota from 1910 until 1918.

Mrs. Potter Palmer is pictured in front of Guptill house. She used the Webb-era houses for guests. She remodeled the houses with modern-day amenities like running water and electricity for her guests' comfort.

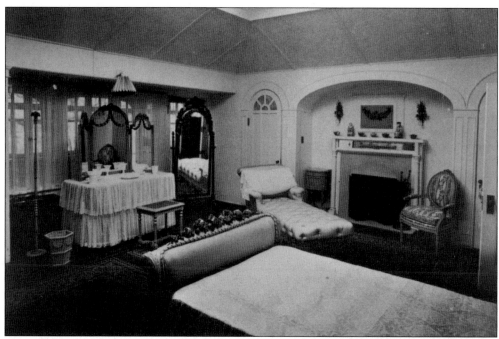

This interior picture of the Oaks shows an elegant bedroom decorated for comfort and style. This was the main base for Mrs. Potter Palmer while she was in Florida.

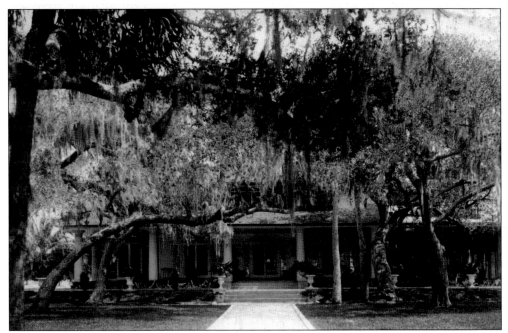

Mrs. Palmer expanded the hunting lodge of Mr. Lawrence Jones, a Kentucky distiller, and renamed it The Oaks at Osprey Point. When finished, the house contained 12 bedrooms and 9 baths, and it was decorated with original art by Degas, Monet, Picasso, and Mary Cassatt. Mrs. Palmer loved the colors blue and white and had 12 china patterns in that color, as well as a blue and white garden. Mrs. Palmer insisted on having modern amenities for her guests, so she installed an independent electric plant and water system for the property. The Oaks was her home base while in Florida, and she also owned Meadowsweet Pastures in Myakka, as well as cottages at Eagle Point in Venice.

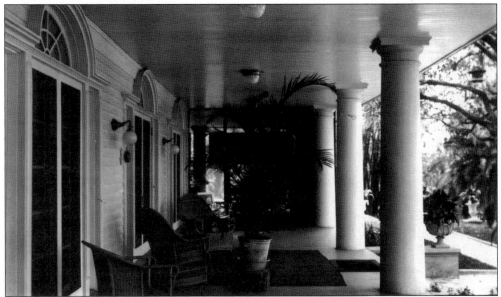

The front porch and veranda of The Oaks had several columns. Large oak trees shaded the house, and the the gardens were designed to be an extension of the house.

The Blue Garden was located in the back of Mrs. Palmer's Oaks house. She wanted a garden that would contain her favorite blue and white flowers and shrubs. The garden had a beautiful trellis covered in blue flowering vines. A round pond had a statue of a little boy in the center.

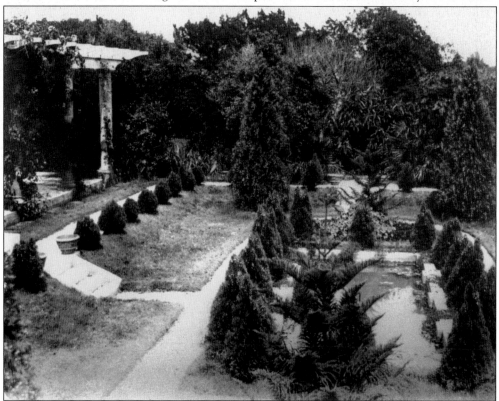

Mrs. Palmer's Sunken Garden was made popular by the French Garden designer, Achilles Duchene, when he made reference to the garden in his 1914 book, *Des Divers Styles de Jardins, Modeles.*

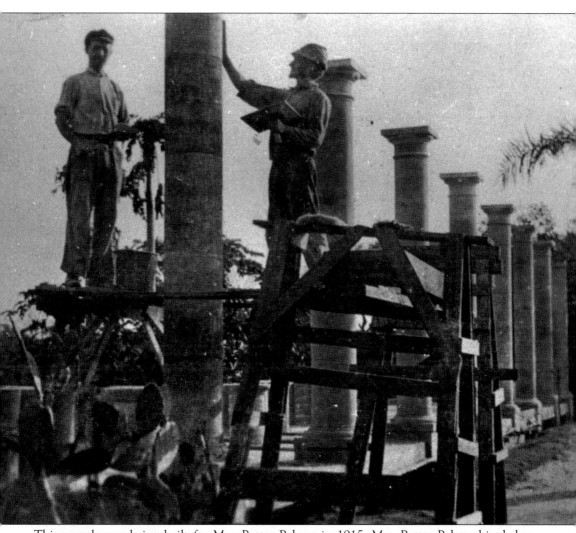

This pergola was being built for Mrs. Potter Palmer in 1915. Mrs. Potter Palmer hired the landscape architects Frederick Law Olmstead and Calvert Vaux, who also designed Central Park in New York City.

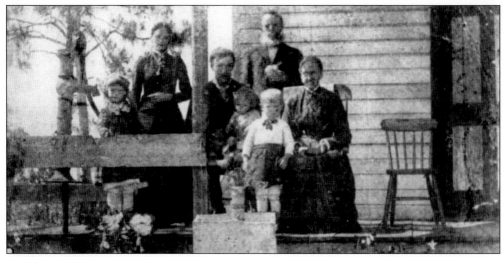

Three generations of Blackburns pose for a picture on the porch in the 1900s. John Slemmons Blackburn and his wife Belinda Fields Blackburn came to Osprey to take advantage of the Homestead Act of 1862. They found a location to homestead that ran from South Creek north to Blackburn Point Road and they also purchased 90 acres. When they moved here from Iowa, only two of their five children, Elvira and George Washington, came with them. Their son, Benjamin Franklin, moved to the area a little later in 1884 to establish a homestead of his own, which ran from Laurel Road to Blackburn Point Road. Shown, from left to right, are Effie Elvira Blackburn, Emma Harriet Blackburn, Benjamin Franklin Blackburn holding Albert Earl Blackburn, and Walter David Blackburn, in front of John Slemmons Blackburn and Belinda Fields Blackburn.

Mary May (Mollie) Wrede Blackburn is pictured in the middle on the back row of this 1905 picture. With her are children Duese, back row, far right, and Herbert, front row, far right. The others are unidentified. Elfred A. Wrede, an early postmaster in Venice, and Rebecca Caroline Knight, daughter of pioneers Jessie and Caroline Knight, were the parents of Mary. She married Albert Earl Blackburn and lived in the Laurel area until she died.

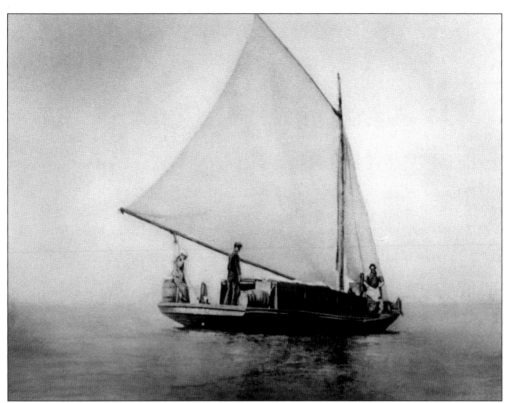

Benjamin Blackburn owned a sailboat named *The Sea Turtle*, which was a shallow draft home-built sailboat, typical of the time. Benjamin made commercial runs in *The Sea Turtle* for many years. His cargo would consist of citrus, produce, hogs, chicken, barrels of guano and cane syrup, local preserves, and marmalades.

This home, pictured in the 1920s, belonged to Albert and Mary Blackburn. The house was built in 1908 at North Bay Shore Road in Laurel and burned down in 1931. Four of the Blackburn's five children were born at this home.

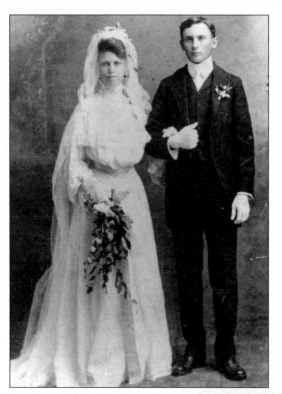

Julian B. Roberts married Effie Elvira Blackburn in 1904 in the Laurel Church on present-day Roberts Road. Effie was the daughter of Benjamin Franklin Blackburn and the granddaughter of John Slemmons Blackburn.

Julian Roberts was one of 12 children who came to this area after the turn of the century. He first lived in Sarasota where he went to school at age 13. He later moved to Lyons Bay and lived with his uncle, who gave him a job cleaning, salting, and packing mullet. After moving to Cuba for a few years, Julian then returned to the area and married Effie E. Blackburn. The couple had four children. Julian taught for 44 years at several local schools, including Woodmere, Englewood, Vamo, Osprey, and Laurel, where he taught from 1928 to 1958. Julian retired at age 72.

Two
PIONEERS

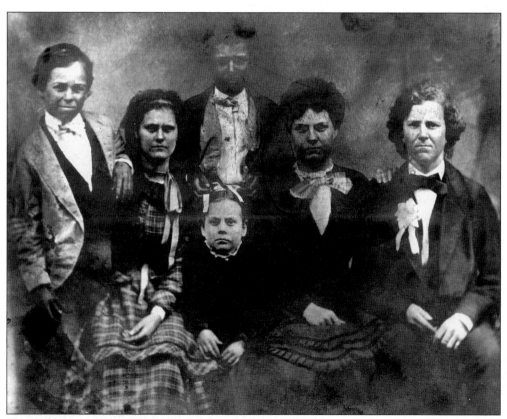

Shown here is a *c.* 1880s portrait of the children of William and Mary Jane Whitaker from Yellow Bluffs. From left to right are William Richard, Louisa Anstey, Hamlin Valentine (upper), Carrie (lower), Nancy Catherine Stuart, and Furman Chairs. Absent from picture are Charles Clarence, Emile Valentine, and Flora Winifred.

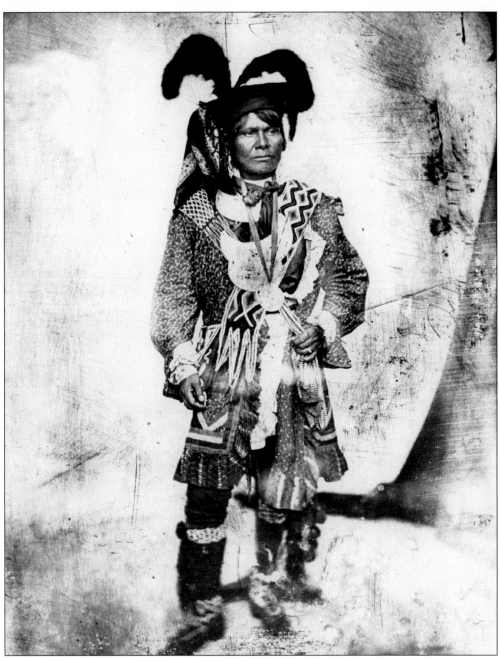

Billy Bowlegs, whose real name was Holata Micco, was the chief of the Seminole tribe that occupied lands in the Big Cypress Swamp. Angered by the treatment of the Native Americans by the white man, he led his warriors during the second and third Seminole Wars. Billy Bowlegs made an impact on Sarasota when he burned down William Whitaker's house on Yellow Bluffs in 1853. Many settlers in Western Florida were killed and homesteads burned by the Native Americans during the Seminole Wars, until the government made arrangements for the tribe to emigrate to the Oklahoma Territory, reportedly with a large settlement paid to Billy Bowlegs for his cooperation. Holato Micco is shown here in 1850 wearing his full regalia.

William Henry Whitaker fought in the second Seminole War. He and his brother, Hamlin Snell Whitaker, came to Sarasota in the early 1840s, when William was in his 20s. He went into the cattle business and sold smoked mullet to the Cuban traders. One of the first people to own land on Sarasota Bay, Whitaker married Mary Jane Wyatt from Manatee, and they were the first couple married at the Manatee Methodist Episcopal Church. The Whitakers had 10 children. They left their home on Yellow Bluffs during the third Seminole War. While living in Bradenton, Native American Holata Micco, also known as Chief Billy Bowlegs, burned down their house.

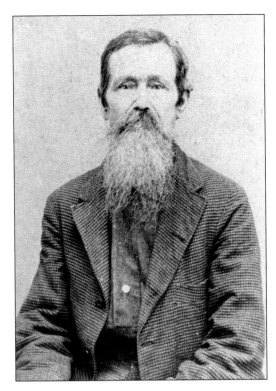

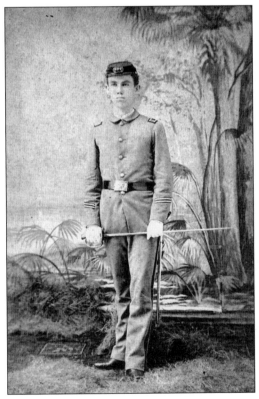

Charles C. Whitaker was the son of the first white settlers in Sarasota, William and Mary Whitaker. This picture was taken of Charles in uniform in 1886 when he attended the East Florida Seminary, which is known today as the University of Florida. He became a successful tax attorney.

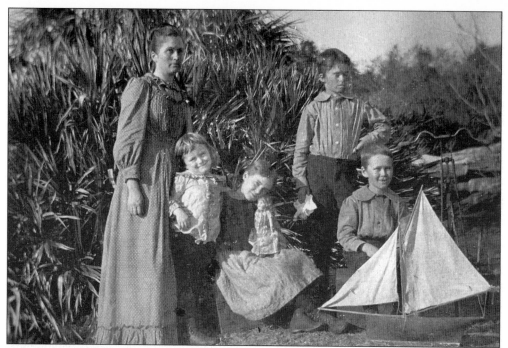

Mrs. Furman Chairs Whitaker poses with her four children on their property at Yellow Bluffs in 1893. The children show off their model sailboat.

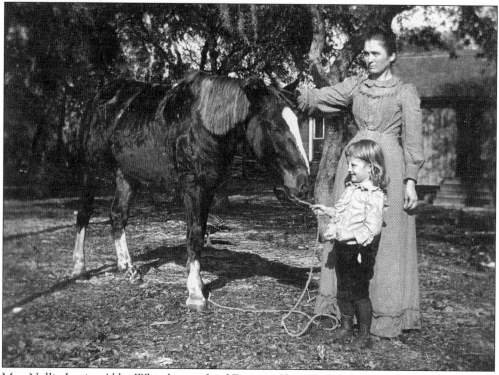

Mrs. Nellie Louise Abbe Whitaker, wife of Furman Chairs Whitaker, and son, Stuart Anstey Whitaker, are shown in 1893 at their home on Yellow Bluffs, Sarasota.

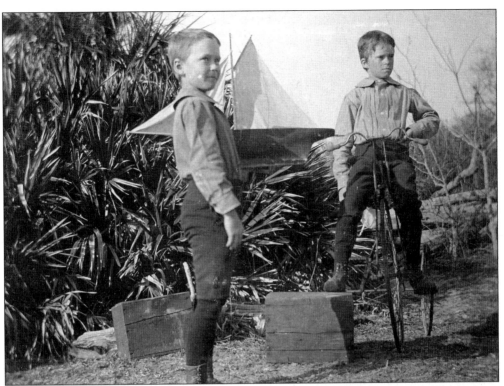

Dwight and Harper Whitaker were photographed c. 1893 playing with a toy sailboat at their home on Yellow Bluffs. The children's father, Furman Whitaker, built two model sailboats. One was described to be big enough to fit a child.

Stuart Anstey Whitaker was the son of Furman Whitaker. He only lived five years.

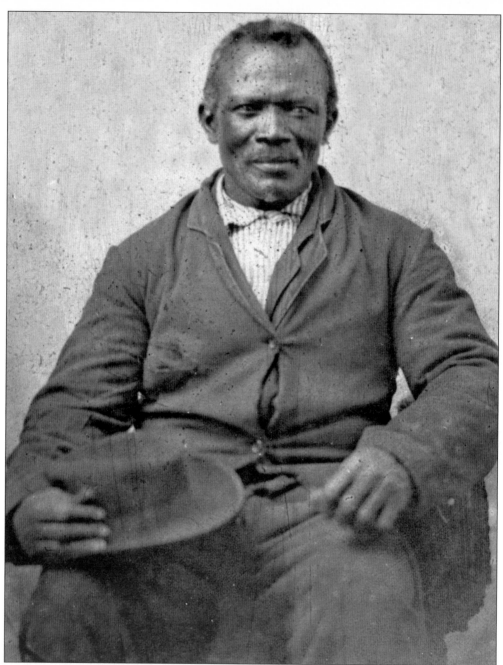

Jeffery Bolding was a slave for William Whitaker. He left the United States for awhile after the Civil War and then returned to the area as an employee for Mr. Whitaker. According to William's son, A.K. Whitaker, in 1857 William found Bolding in Florida. He was a runaway slave from North Carolina. William bought him from his owner by locating the owner in North Carolina and legally purchasing him. At the end of the Civil War, Bolding and his wife, Hannah, left the area to go to the West Indies. Bolding returned alone and worked for William Whitaker as an employee until he died at age 70 in 1904. He is buried in Adams Cemetery located in Bradenton.

The Jane Gault and John Browning family came to Sarasota from Glasgow, Scotland in 1885.

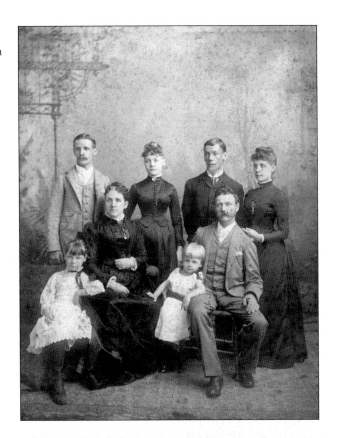

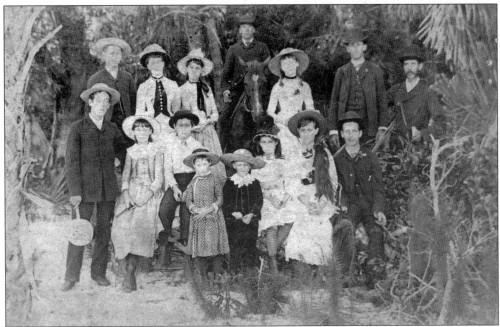

Two pioneer families, the Brownings and the Whitakers, enjoy a picnic at Cedar Point in 1886. Today the area is called Golden Gate Point.

Several families arrived in Sarasota from Scotland in 1885, including the Brownings. This photograph shows Jane Browning with her daughters, Ewina, Margaret, and Jessie.

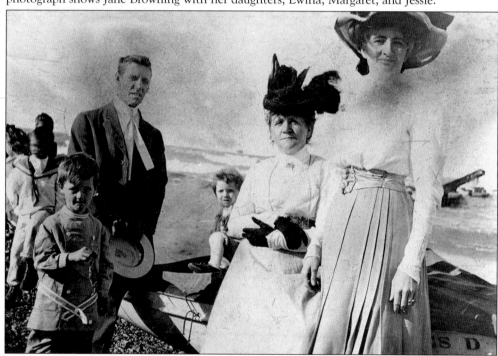

Like many colonists, the John Brownings of Paisley, Scotland came to Sarasota in hopes of starting a new life. They were one of the few families to stay in Sarasota. John Browning was a lumber mill owner and craftsmen in Scotland. He built houses and buildings for the Florida Mortgage and Investment Company. This photograph shows, from left to right, John W. Browning, Hugh Kerr Browning, Jane Kerr Browning and Jean McDaniel.

Charles E Abbe moved to Sarasota in 1876 and became the first postmaster of what was then known as "Sara Sota" in 1878. He changed the name to Sarasota when he registered for a post office. Abbe was a large landowner. He also owned a store and home on Hudson Bayou, where Selby Gardens is located today. A group of vigilantes were afraid he was selling them out to the land grabbers and murdered him in 1884.

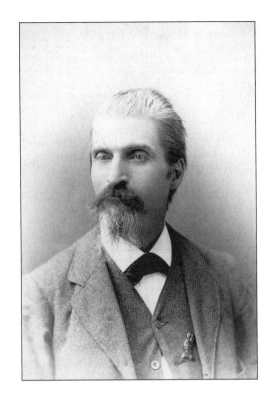

Carrie Spencer Abbe Kleinoscheg was the daughter of Charles Abbe and sister to Nellie Louise Abbe Whitaker. She was an honorary lifetime member of the Woman's Club of Sarasota and a founding member of the Town Improvement Society. She married an Austrian named Anton Kleinoscheg Jr., who invested in the Scottish Colony and came to Sarasota in 1885.

NUMBER	SENT BY	REC'D BY			
248 C	au	MB	16 Paid	Via Jacksonville	CHECK

Received at ____ 50 Pm Dec 29 1884.

Dated Tampa Fla 29 01665

To J N Adams

119 So Water

Uncle .. Father was shot and
Killed This Pm December twenty
Seventh dont allow Carrie to
Come Nellie Whittaker

Charles Abbe's daughter Nellie, who later married Furman Chairs Whitaker, sent her uncle a letter through The Western Union Telegram Company informing him of her father's murder in 1884. Several men were found guilty in association with the murder, and two were convicted. They were convinced that Charles Abbe was a spy for the land grabbers and thought he was informing them where the property lines were. To make sure they did not lose their land, they murdered Charles Abbe.

This picture of Nellie Abbe was taken for her graduation in 1877 in Lawrence, Kansas shortly before her family moved to Sarasota. Nellie was the daughter of Postmaster Charles Abbe and sister to Carrie Abbe. She married Furman Chairs Whitaker and lived at Yellow Bluffs

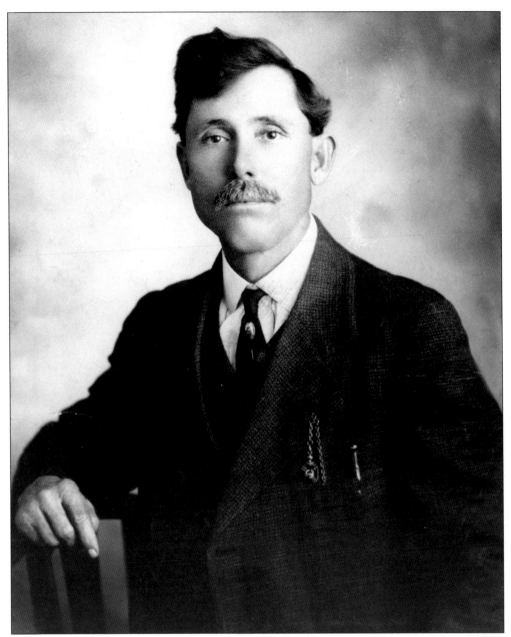

Born in Sarasota in 1874, Arthur B. Edwards was a respected figure. Although he was orphaned in his early teens, Edwards became successful in the cattle business and eventually opened a real estate business and insurance company. He also worked with Joseph H. Lord, a large landowner, for over a decade. In 1910, Edwards arranged for Mrs. Potter Palmer to come and stay in Sarasota for her initial visit. He renovated Halton's Sanitarium to provide her with suitable lodging. The sanitarium was emptied of patients and furnished like a private estate. He helped to convince her to invest in Sarasota. Two of Edwards's accomplishments included building the Edwards Theater in 1925 and serving as mayor of Sarasota in 1914–1915 and 1920–1921. His diligence helped pave the roads and build the Tamiami Trail.

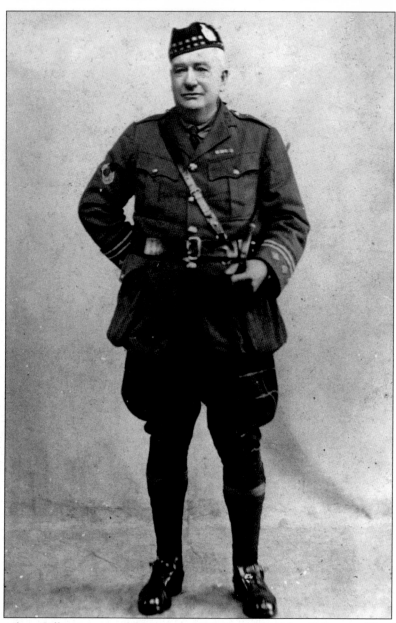

Col. J. Hamilton Gillespie came to Sarasota in 1886. Son of Sir John Gillespie of Scotland, who was a director of the Florida Mortgage and Investment Company, Col. J. Hamilton Gillespie was named manager of FM&I, which promoted development of the new town of Sarasota. He brought his love for golf here and built the first golf course in the area. Colonel Gillespie was Sarasota's first mayor when Sarasota became a town in 1902 and served five consecutive terms. He also was a justice of the peace and a real estate broker. He sold lots on Main Street for $100 and farmland for $3 an acre. Gillespie married twice, first to Mary McIvor Gillespie and then to a local woman named Miss Blanche McDaniel. He sold his remaining land to Owen Burns in 1910 for the sum of $35,000. Colonel Gillespie donated roads for downtown and the Rosemary Cemetery where he was buried. He died playing his favorite sport, golf, on the 110-acre golf course that he built in Sarasota.

Taken in 1891, this photograph depicts Mrs. Mary McIvor Gillespie, the first wife of Col. J. Hamilton Gillespie. In 1890 the Gillespies moved to Bradenton. After visiting Scotland, Colonel Gillespie returned alone, either divorced or widowed.

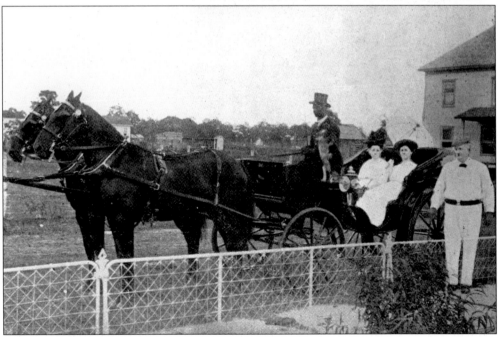

In this 1905 photograph, Colonel Gillespie stands next to the buggy. In the buggy on the right is Colonel Gillespie's second wife, the former Blanche McDaniel. On the left is Mrs. Charlie Swain, sister of Mrs. Gillespie. The coachman is Leonard Reid. In the background can be seen the house of Judge McDaniel, the father of Blanche Gillespie.

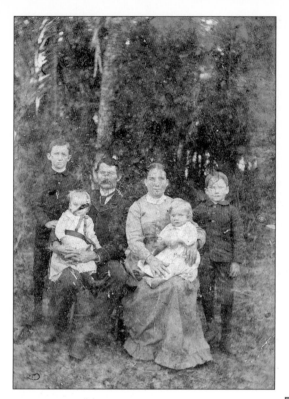

The Tuckers were early settlers of Fruitville. From left to right are Oscar Frank Tucker, Frank Tucker (seated) holding Mattie Tucker Gant, Eunice Coker Turner (seated) holding Ethel Turner, and Jesse H. Tucker.

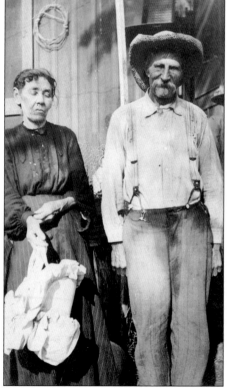

Peter and Sophie Crocker lived in a small community located between Hudson Bayou and Phillipi Creek. They came to Sarasota from Key West in 1870. They lived in a lean-to for awhile and then bought a 20-acre lot on Bee Ridge for the site of a house.

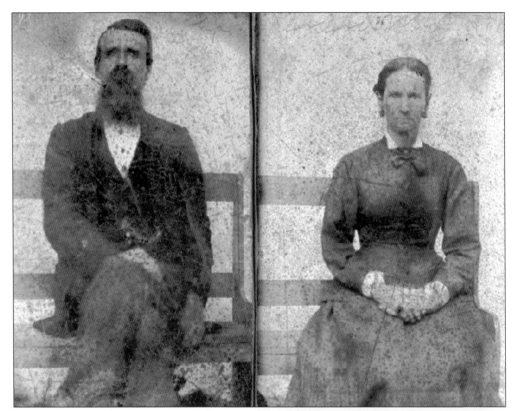

Rev. Isaac Redd and his wife Elizabeth Brown Redd were the founders of the Bee Ridge area, which they named after the large amount of bees there. Isaac fought with the Confederate army. He married Elizabeth Brown in 1867, and built the first church in Sarasota County, a missionary Baptist church called Friendship Baptist Church. The church started with a circuit-riding preacher.

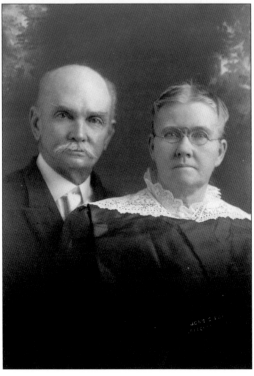

Mr. and Mrs. Charles Reaves homesteaded and founded Fruitville in 1876. Charles and his wife Martha Tatum had four children. A generous man, he bought land to build the first Fruitville school and then donated it to the school board. Charles was the first postmaster and owned the second phone. He paid for part of the cost to have a road paved from Sarasota to Fruitville. In 1903, the councilmen awarded Charles Reaves a contract for hard surfacing; he rebuilt sidewalks out of lumber downtown.

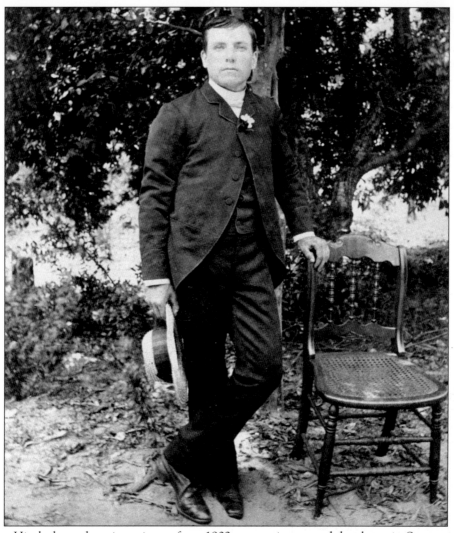

Harry Higel, shown here in a picture from 1902, was a pioneer and developer in Sarasota. He started the Siesta Land Company and, with his partners E.M. Arbogast and Louis Roberts, began development of the north end of Siesta Key on the Gulf in 1907, changing the name from Sarasota Key to Siesta Key. (Over the years, Siesta Key has been called Clam Island, Muscle Island, and Little Sarasota Key.) Higel purchased and ran the schooner *Vandalia* in 1907 when the schooner S.S. *Mistletoe* could not afford to continue running passengers and cargo—including fish and ice—from Tampa to Sarasota. In 1913 Higel Avenue was built and honored with his name. Higel built the glamorous Higlehurst Hotel in 1915, which contained a 150-seat dining room, only to have it burn down in 1917. In 1907, Higel built the first yacht club in Sarasota, called the Sarasota Yacht Club, which was located on Siesta Key. Higel juggled many jobs. He was appointed postmaster for the Siesta Key Post Office. He purchased the dock at the end of Main Street and was the local agent for John Savarese's Tampa Steamship line. He worked to have Sarasota incorporated and to get phone lines installed, dredged canals, and was elected mayor three times. Higel, A.B. Edwards, and John Burket were all credited for the building project and getting people to vote for a bond to build a bridge from the mainland to Siesta Key. Unfortunately, Harry Higel met an untimely end when he was murdered on the island in 1921. His killers were never found.

Four generations of Whitaker women are shown here in this family portrait. From left to right are (front row) great-granddaughter Gee Gee Sturgis and grandmother Mary Jane Whitaker; (back row) granddaughter Gertrude Higel and daughter Louisa Edmondson.

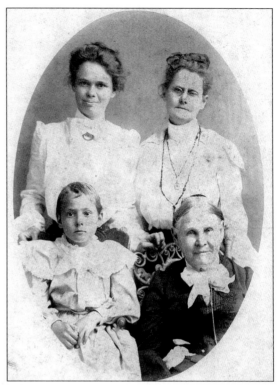

Gertrude Higel, wife of Harry Higel, and their two children, Genevieve and Louise, are all dressed up for swinging in 1902.

Dave and Ada Broadway are seen in front of their house on Palm Avenue. Dave was a successful entrepreneur and ventured into many businesses—from running a mail carriage and operating an ice cream stand to opening an oyster house on the docks and eventually opening a restaurant in the Hover Arcade.

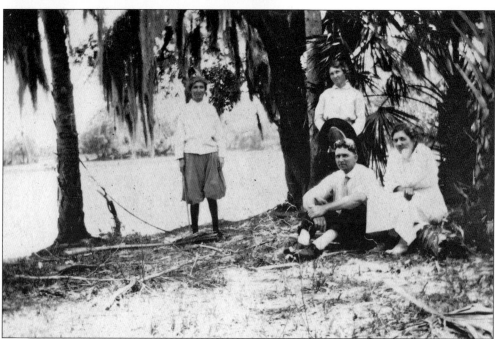

Dave and Ada Broadway are pictured with friends. Dave was an area native who moved from Fruitville to Sarasota in 1893.

Luke and Annie Wood came to Sarasota from Woonsocket, Rhode Island. They wintered here for many years and finally settled here in 1896 with their daughter Ethel.

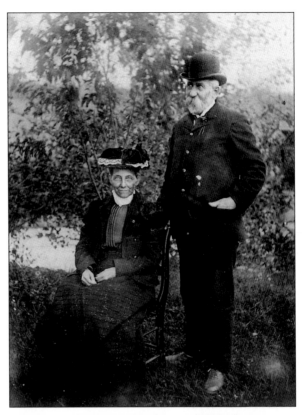

Annie S. Wood was originally from Hannibal, Missouri. She married Luke Woods in 1886.

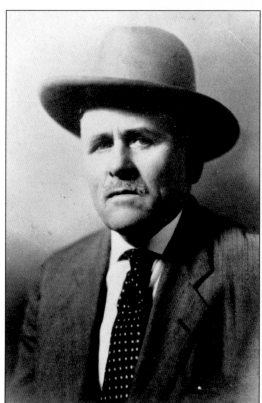

Leon D. Hodges moved to the Englewood area in 1888 and eventually moved to Sarasota in 1900. He was elected to be the town marshal and then chief of police. When Sarasota separated from Manatee County in 1921, Hodges became sheriff for Sarasota County.

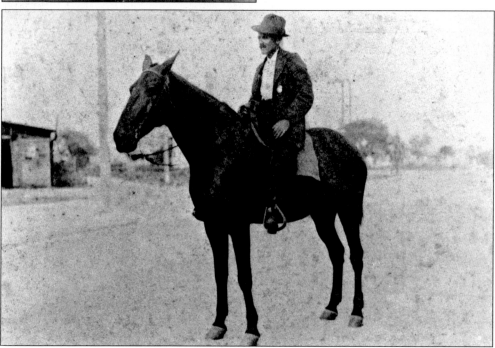

Leon D. Hodges was Sarasota's law enforcer for two decades. This c. 1910 picture shows that the horse was still used to patrol the town.

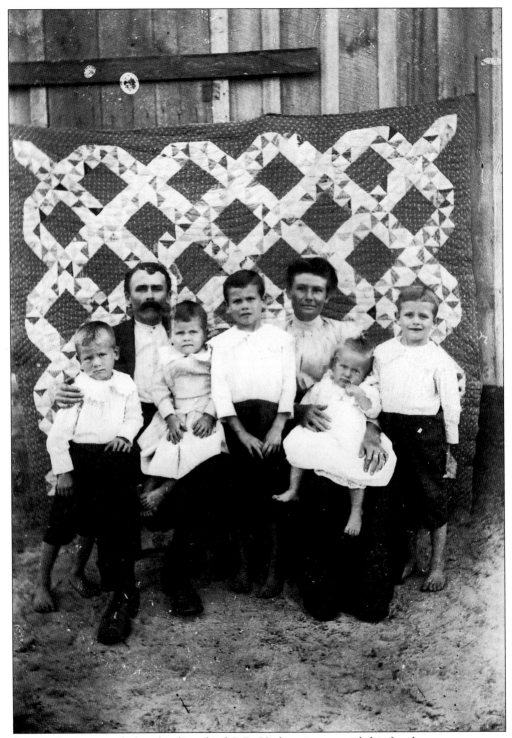

Sarasota's town marshal and police chief, L.D. Hodges, is seen with his family.

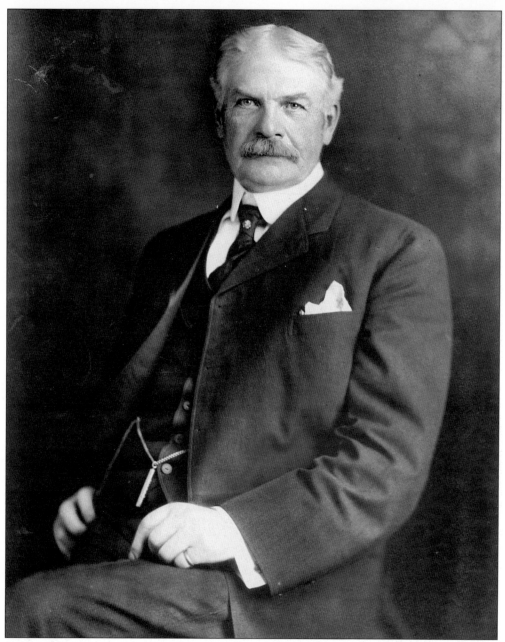

Calvin Payne was an oilman and generous benefactor while living in Sarasota. He donated 60 acres of land downtown for a park and ball field, which was used for spring training for the New York Giants, Boston Red Sox, and Chicago White Sox. Payne wintered in Sarasota from 1917 until 1926.

The Matthew C. Jones family poses for the camera in 1910. From left to right are Mrs. M.C. Jones, Myra Jones Hutches, Mazie Welch Luzier (a friend), and M.C. Jones. Mr. Jones owned a lumberyard in town.

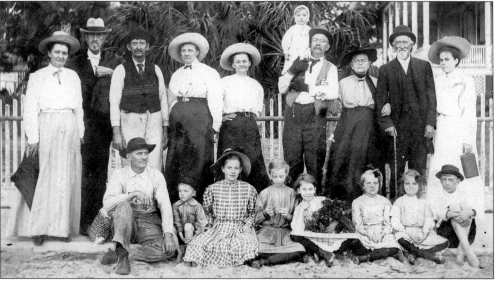

Pictured at a gathering of the Seale family are, from left to right, (front row) Charlie Seale, Robert Finney, Marguerite Seale, Ruth Seale, Angeline Finney, Louis Seale, Emily Finney, Perry Finney, and Robert A. Seale (who moved to Sarasota in 1904 and served in the Confederate Army); (back row) Angie Seale Keener, J.W. Keener, Eddie Seale, Emmie Seale, Betty Seale Finney, unidentified, Billy Bevins, Mrs. R.A. Seale, Rev. R.A. Seale, and unidentified.

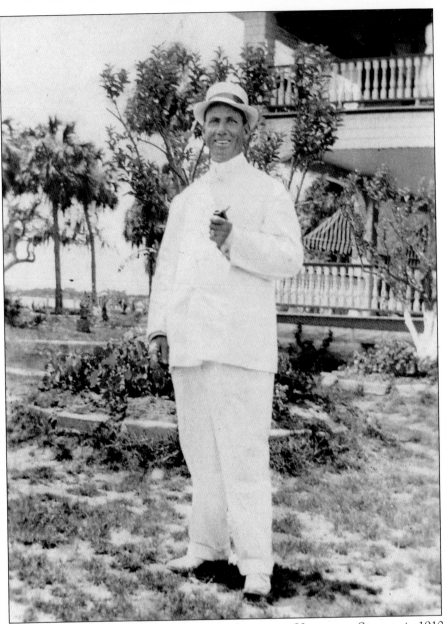

Owen Burns was instrumental in sprucing up the downtown. He came to Sarasota in 1910 from Chicago. Sarasota provided him with many opportunities, including great fishing to satisfy his love of the sport and lots of undeveloped land on which to build. Burns insisted that a seawall be installed downtown and had the area cleaned up to attract tourists. He bought all of the land owned by Col. John Hamilton Gillespie and the Florida Mortgage Investment Company, which made him the largest landowner in 1911 with holdings estimated to be more than 75 percent of the city. He founded the Burns Realty Company and Construction Company. He was vice-president of John Ringling Estates and exclusively sold the lots on Lido and St Armands. His construction company was responsible for building the causeway to these islands. Burns also built several other buildings, including The El Vernona Hotel, which was named after his wife, and Burns Court.

Three

COMMUNITY

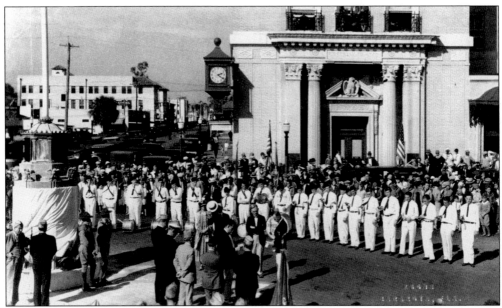

During the Armistice Day celebration in November 1928, the American Legion war Memorial was dedicated, with the American Legion Drum and Bugle Corps, Sarasota Bay Post #30, present. The dedication of the monument was held at Five Points by the American Legion with Harrison E. Barringer as the master of ceremonies.

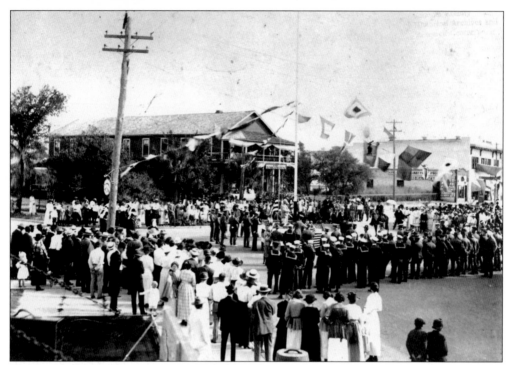

The first Armistice Day ceremony was held at Five Points in 1919. Over 200 Sarasotans came to cheer for the soldiers returning from World War I. All of the soldiers returned except one who died of pneumonia. You can see "The Sarasota" which became the Palmer Bank. The Virginia Theater is seen east on Main Street next to some small businesses.

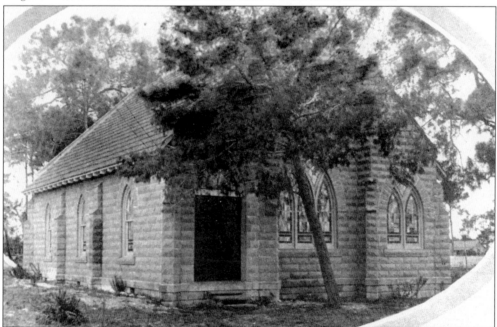

Shown c. 1920 is the First Presbyterian Church, which was located on Orange Avenue. After the real estate boom, a new Mediterranean Revival Sanctuary was built.

The Methodists were one of the first organized church denominations in Sarasota. They first met in a frame building at Five Points with circuit-riding preachers from Manatee. By 1906 they bought this building on Main Street and Pineapple Avenue and added a steeple and belfry. In the foreground is thought to be the first telephone lines, installed in 1903.

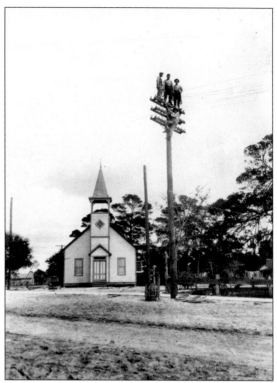

The Episcopal Church of the Redeemer, shown in this 1905 picture, was built in 1904 and located on Pineapple Avenue. The church started with a dozen members but soon grew too large for the space. With the help from Dr. Halton and Col. J.H. Gillespie, the church was moved to Palm and Strawberry and then remodeled. Finally, it was moved again in 1908 to Morril Street and South Orange Avenue.

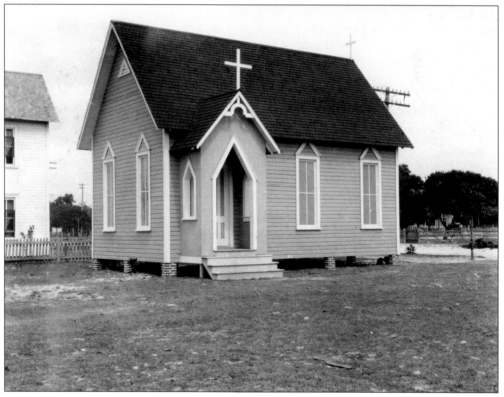

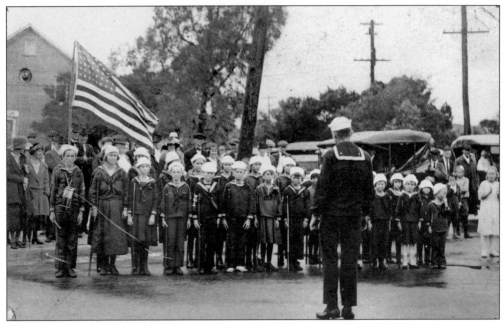

George Lamb Thacker and C. Hitchings organized the first Sea Scouts in 1912, the same year this picture was taken. Thacker was a jeweler who worked out of the Badger Drug Store. He eventually started the Thacker Funeral Home, located on Orange Avenue.

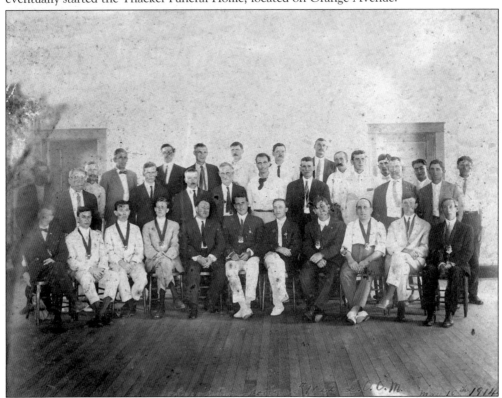

Order of the Moose is shown sitting at the Sarasota Lodge in 1914.

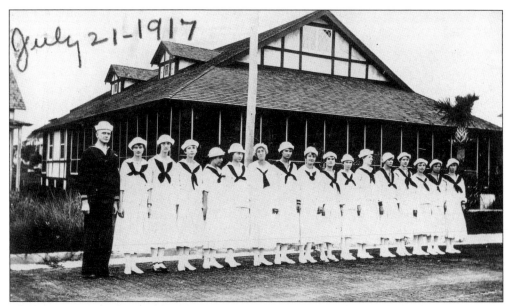

The Sarasota Girls Naval Militia were trained in exhibition drills for parades. They are shown here in 1917 standing in front of the Women's Club. The drillmaster, Henry Grinton, led drills on Main Street during parades in downtown Sarasota.

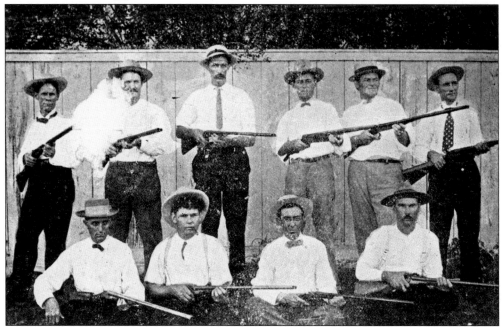

Shown is the Sarasota Gun Club in 1907. From left to right are (front row) R.I. Kennedy, owner and operator of a furniture store; Zeke Messer, hardware employee; Clarence Hitchings, banker; and J.W. Harvey, owner and operator of a blacksmith shop; (back row) C.C. McGinty, lumberyard employee; George W. Blackburn, owner and operator of a hardware store; C.M. Jones, lumberyard employee; Jake Chapline, realtor; Asa Chapline, realtor; and Hamden S. Smith, known as Ham, owner and operator of a dry goods store. The team held a record for never having been beaten.

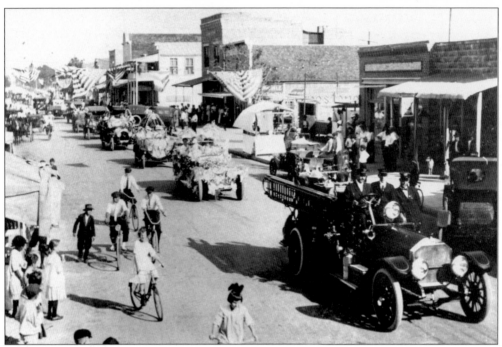

Sara De Soto pageant was a tradition in Sarasota for many years, including parades, parties, and pageants. This 1916 picture shows the parade through town.

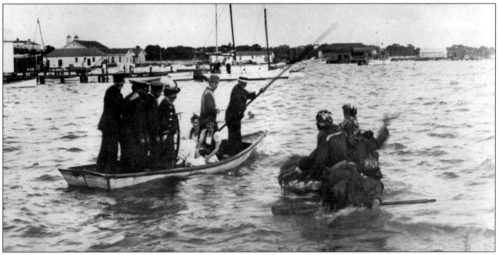

An old legend, written by George F. Chapline in 1906, on which the Sara De Soto parade is based, claims that when Hernando de Soto came to this area, he brought a daughter named Sara. De Soto's men captured a young Indian Prince, named Chichi-Okobee. He fell ill during captivity and Sara asked if she could nurse him. With Sara's nurturing he became well. Then Sara fell ill and the Indian Prince asked if he could nurse her. He went back to his tribe and brought the medicine man back to help cure Sara. Sadly, Sara died. The young Indian prince collected 100 braves. They canoed out into Sarasota Bay to bury Sara. Legend has it that after they lowered her body into the water, they sank their canoes vowing to protect her for all eternity. This picture shows the re-enactment of this event, with Genevieve Higel Sturgis playing the role of Sara de Soto.

On March 21, 1916, Mayor Harry L. Higel meets the explorer de Soto and daughter Sara, as they land at the Belle Haven Inn dock, and presents them with the key to the city. De Soto is portrayed by I.R. Burns; Sara de Soto is portrayed by Genevieve Higel Sturgis.

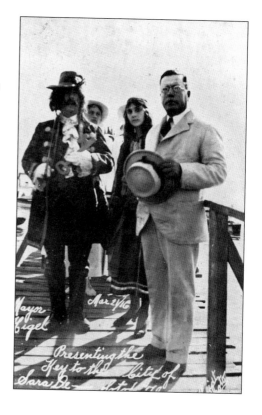

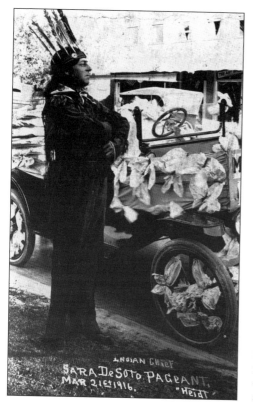

INDIAN CHIEF
SARA DeSOTO PAGEANT,
MAR 21ST 1916. "Heidt"

In the first Pageant of Sara De Soto, which took place in 1916, Jake Chapline Jr. is an Indian chief. Some say that Sarasota was named after Sara de Soto. However, there is no proof that Hernando de Soto had a daughter named Sara or that he ever captured a young Indian Prince named Chichi-Okobee.

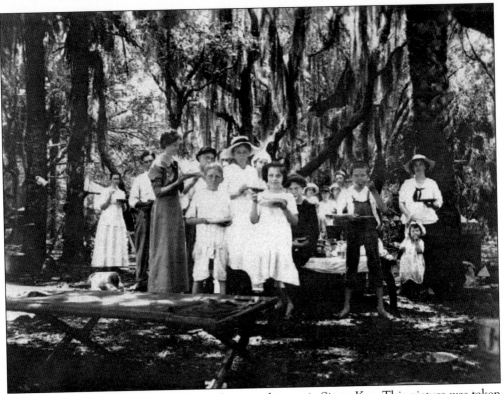

Many children and adults enjoyed picnicking on the scenic Siesta Key. This picture was taken sometime in the early 1900s and shows how unspoiled the island was.

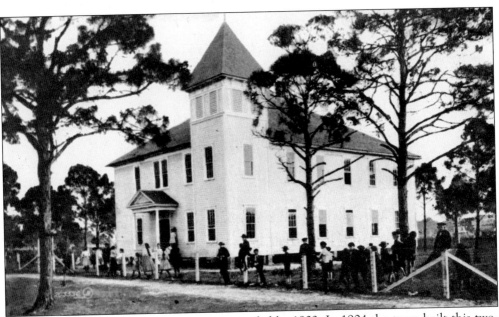

The first school built in Sarasota was overcrowded by 1903. In 1904 the town built this two-story building, shown c. 1904, which served the children of Sarasota until 1913.

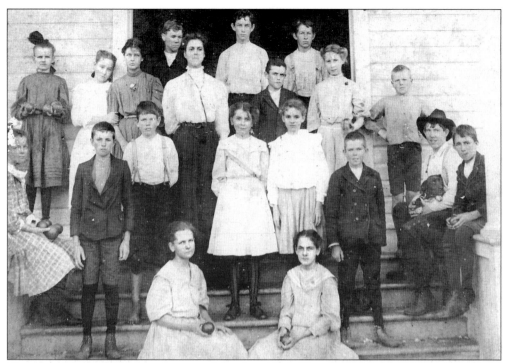

This photograph depicts the Sarasota School in 1910. The child sitting down on the right is Gertrude Turner. Standing behind her to her right is John Pelot. Next to the doorway on the right is Mamie Ross Pickett. Behind her is Roy Bradley. The teacher in the center is Mrs. McCall. To the left behind the teacher is Leonard Rudd.

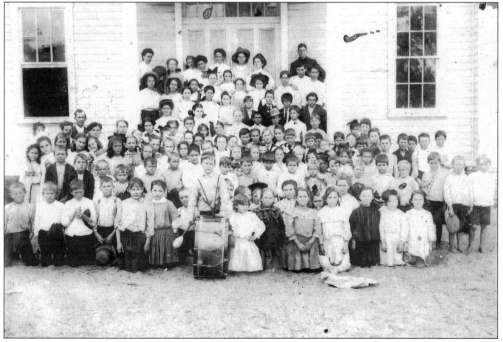

Charles L. Reaves founded this school in Fruitville. This is the class of 1910.

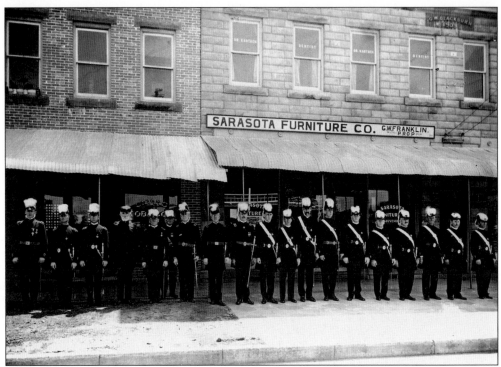

The Trinity Commandry 16, Sarasota Commandry, Knights Templar lined up in front of the G.W. Blackburn building on the southeast corner of Main and Palm Avenue in 1918.

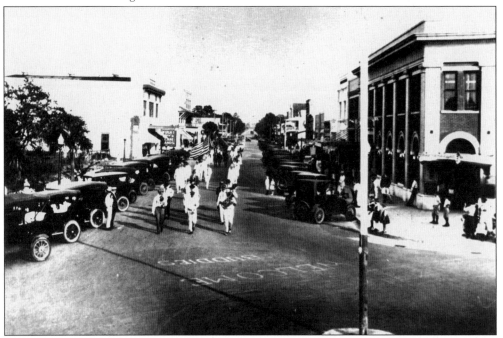

In 1918 Sarasota welcomed home their soldiers from World War I. The first flag pole was put up in their honor. The vacant lot on the left is where the First Bank and Trust, later named the Palmer Bank, was built.

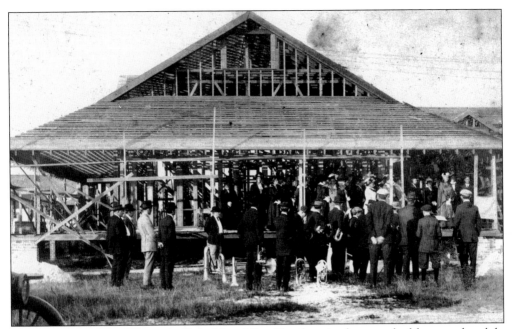

The president of the Women's Club, Mrs. Alice Gunther, is photographed here at the club, delivering an address at the corner of Park and Palm on January 1, 1915. The Women's Club has been active in the community since 1913. They had a ceremony in 1915 when the cornerstone was placed for the new clubhouse. They had 65 charter members in 1915.

The Women's Club members dressed up for a Mother Goose party in 1916. At that time the club was located on the corner of Park Street and North Palm Avenue. The Women's Club enjoyed social events, but their main purpose was to help beautify Sarasota. They planted over 200 palm trees and pushed to get the streets and sidewalks paved.

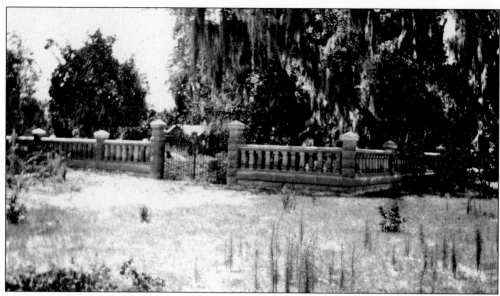

This is the Whitaker family cemetery, located near their home on Yellow Bluffs, near present-day Twelfth Street. Enclosed in 1910 by family member Charles C. Whitaker, the cemetery was deeded to the Sara de Soto Chapter of the Daughters of the American Revolution in the 1930s so that long-term care could be provided. William and Mary Whitaker and many other family members have been buried in this cemetery, pictured c. 1915.

THE UNITED STATES OF AMERICA,

To all to whom these presents shall come, Greeting:

Deed to Siesta Key

Whereas *Thomas G. Edmondson of Manatee County Florida*

CERTIFICATE No. 3945

haſ deposited in the GENERAL LAND OFFICE of the United States a CERTIFICATE OF THE REGISTER of the Land Office at *Gainesville Florida* whereby it appears that Full Payment has been made by the said *Thomas G. Edmondson* according to the provisions of the Act of Congress of the 24th of April, 1820, entitled "An Act making further provision for the sale of the Public Lands," and the acts supplemental thereto, for *the lot numbered two of section thirty six in township thirty six south, of range seven teen east of Tallahassee Meridian in Florida, containing seventy nine acres and nine ty two hundredths of an acre*

according to the OFFICIAL PLAT of the Survey of the said lands, returned to the GENERAL LAND OFFICE by the SURVEYOR GENERAL, which said Tract haſ been purchased by the said *Thomas G. Edmondson*

Now know ye, That the United States of America, in consideration of the premises, and in conformity with the several Acts of Congress in such case made and provided, Have given and granted, and by these presents Do give and grant, unto the said *Thomas G. Edmondson* and to *his* heirs, the said Tract above described; To have and to hold the same, together with all the rights, privileges, immunities, and appurtenances, of whatsoever nature, thereunto belonging, unto the said *Thomas G. Edmondson* and to *his* heirs and assigns forever.

In testimony whereof, I, *Chester A. Arthur*, President of the United States of America, have caused these letters to be made Patent, and the seal of the GENERAL LAND OFFICE to be hereunto affixed.

Given under my hand, at the CITY OF WASHINGTON, the *thirteenth* day of *February*, in the year of our Lord one thousand eight hundred and *eighty four*, and of the Independence of the United States the one hundred and *eighth*.

By the President:

Chester A Arthur

By *M. H. Roots*, Secretary.

S. W. Clark, Recorder of the General Land Office.

RECORDED, Vol. *6*, Page *158*.

This deed, signed by then President Chester A. Arthur, was to acquire 80 acres of land on Siesta Key. Thomas G. and Louise Whitaker Edmondson acquired the land in 1884.

The home of Furman Chairs and Nellie Whitaker, located at Yellow Bluffs in Sarasota, is shown here c. 1893. Furman Whitaker married Nellie Louise Abbe, who was the daughter of postmaster Charles Abbe.

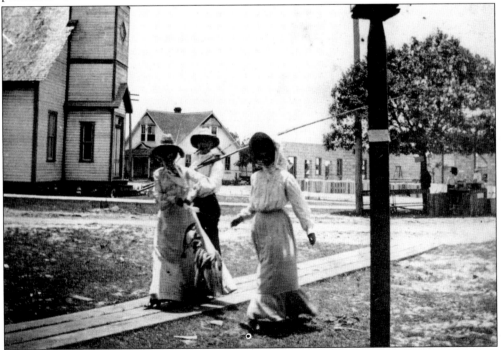

Townspeople are seen here crossing through Five Points in downtown Sarasota, c. 1904. Back from a day of fishing are F.W. Schultz, Mrs. Schultz (holding their catch), and Mrs. Morris, who ran the Sarasota House. Badger Drug Store can be seen under construction in the background.

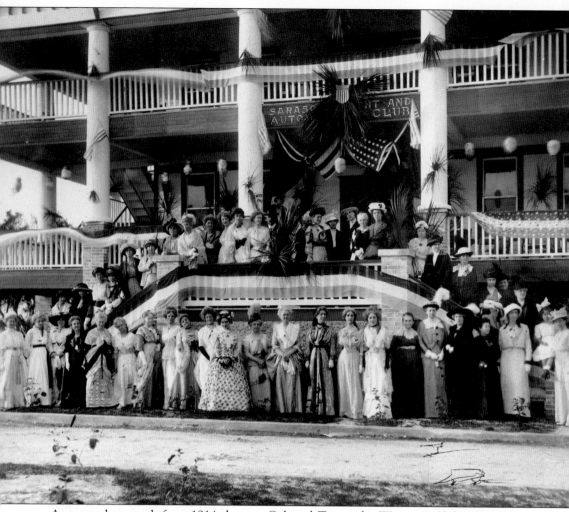

A group photograph from 1914 shows a Colonial Tea at the Women's Club. The Women's Club of Sarasota helped to improve the condition of the town. They pushed to have streets and sidewalks paved, they planted trees to make the town look more aesthetically pleasing, which attracted tourists. Here the Women's Club is celebrating a Colonial tea.

Four

AGRICULTURE

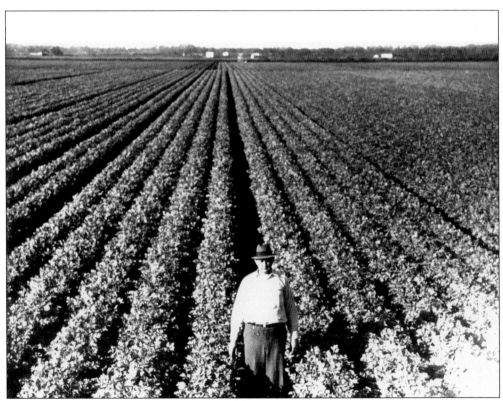

Several farmers grew and shipped celery in Sarasota. Many of them were part of the co-op created by the Palmer brothers.

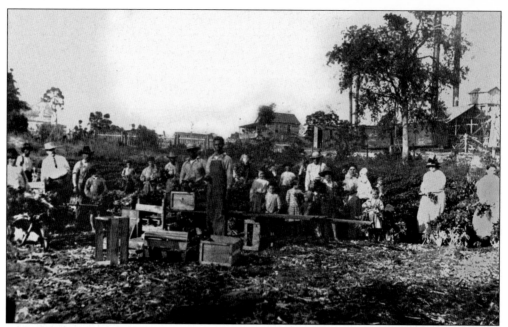

This celery farm was located downtown on the future site of the Mira Mar Hotel.

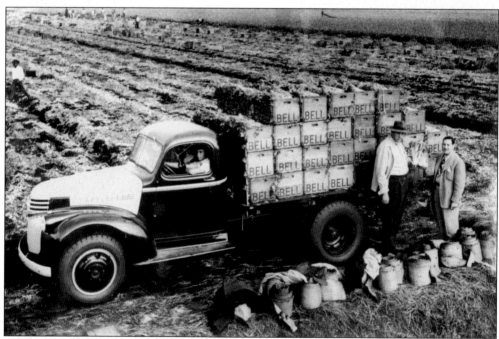

In 1923 the Sarasota-Fruitville Drainage District was formed. Eight thousand acres were drained near Fruitville, including 2,000 acres of rich soil to be used for growing celery. This project was made possible by Honore and Potter Palmer Jr. at a cost of $600,000. The Potters started a co-op of celery growers and sold tracts of land to farmers. The project started in 1924 and the first plantings occurred in 1927. Tom Bell and his brother made Sarasota famous for celery. They had several fields of celery, which they shipped north on refrigerated railway cars.

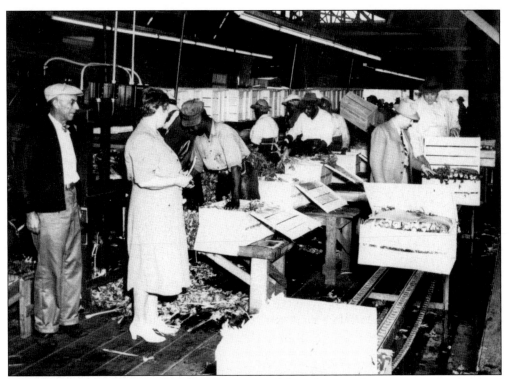

These workers are packing celery for shipment north by refrigerated train car.

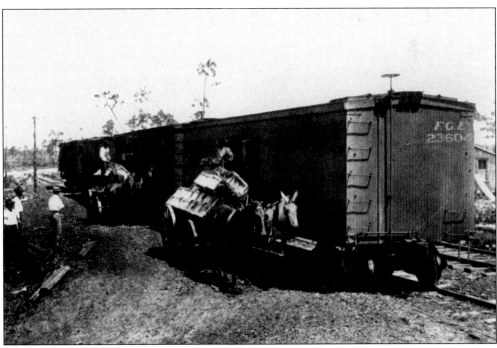

When loading celery at Bee Ridge Road, station farmers would load 40 crates in each wagon and up to 350 crates per car. The cars were refrigerated to keep the celery fresh.

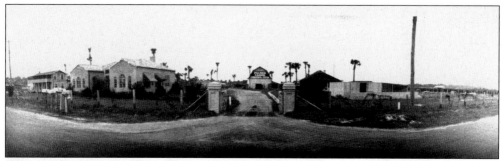

Palmer Experimental Farm was owned and operated by Honore' and Potter Palmer, Jr. They drained the area and then added lime and ground limestone to balance the acid muck, which was left after the drainage.

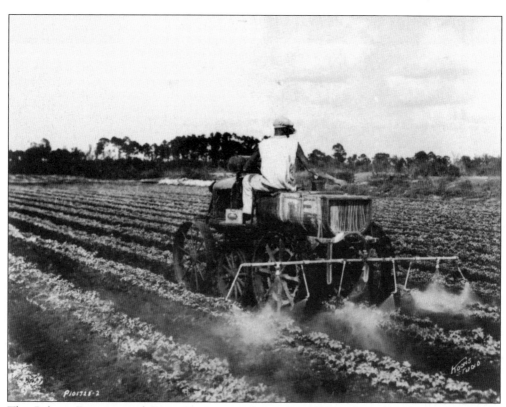

The Palmer Experimental Farm Station was located on Richardson Avenue and Fruitville Road. The station provided the farmers with information about and tests on soil fertility, seed, fertilizers, irrigation, and drainage.

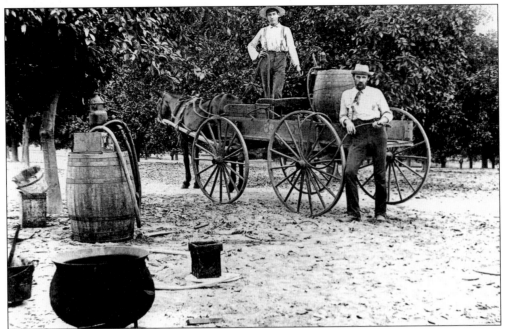

Throughout Sarasota's history, citrus has been an important agricultural product. During the winter of 1894–1895, temperatures fell below 17 degrees, killing several vegetable and citrus crops. Farmers in this area were spared the majority of the devastation, which attracted many new settlers to this area from northern Florida.

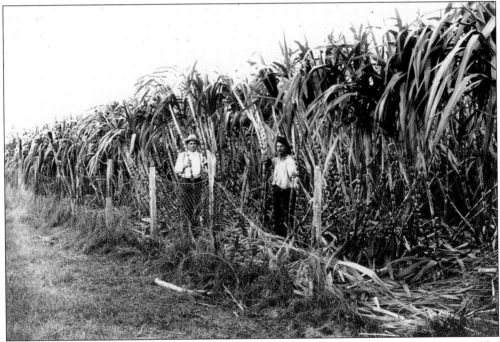

Sugar cane was a big product in Sarasota. Many farmers produced sugar cane for money. The Webb family, who arrived and lived on Little Sarasota Bay in 1867, produced sugar cane for their first cash crop.

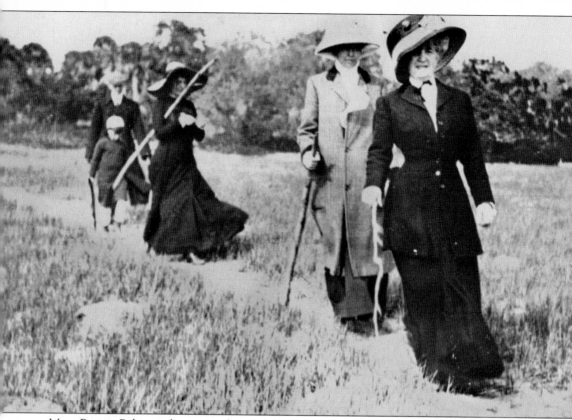

Mrs. Potter Palmer, shown in front, named her 15,000-acre farm, located in Myakka, Meadowsweet Pastures. She was a member of the Florida State Livestock Association and tried to run Meadowsweet Pastures as a role model for farms in the area. She was unhappy with the way the local cows looked, so she decided to dip her cows in vats of insecticide to control disease. She also put up fences to try and keep out the neighbor's tick-infested cows. The local cattleman, known as "crackers," did not appreciate her foresight. They were upset that she was not allowing their cows free range of her Myakka River pastures, so they would cut her fences. She traveled to her farms in a Ford Model T, usually bringing family members and a retinue of servants with her.

Pictured sometime between 1912 and 1918 are dipping vats full of insecticides at Meadowsweet Pastures. This process was pioneered by Mrs. Potter Palmer to prevent the cows from getting disease.

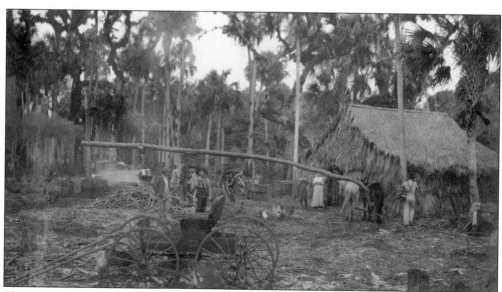

This picture shows John Havelston grinding sugar cane into syrup.

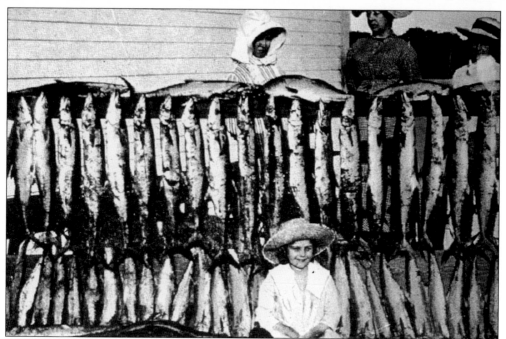

In the 1800s and early 1900s, fish were abundant in Sarasota Bay. In 1895 Sarasota was called a fishing village and its fishing industry began to flourish. In the early 1800s Cuban fishermen lived up and down the bay, and in the early 1840s William Whitaker caught and salted mullet to sell to the Cuban traders. In 1884 the market for dried or salted fish declined and fresh fish became more desirable, due in part to the railway in Tampa, which provided a way to transport fish on ice to other parts of the country. Sarasota did not benefit from the railway until a pass was dredged and steamships could come to the docks.

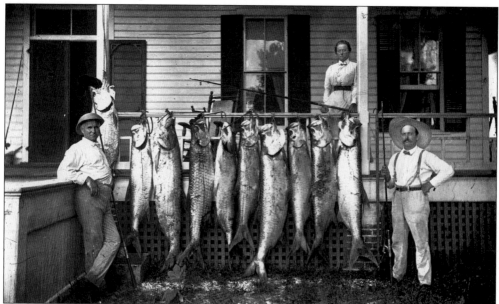

Fish were numerous in Sarasota Bay during the late 1800s. A few proud guests show off their catches at the Belle Haven Inn in the 1890s.

Five

TRANSPORTATION

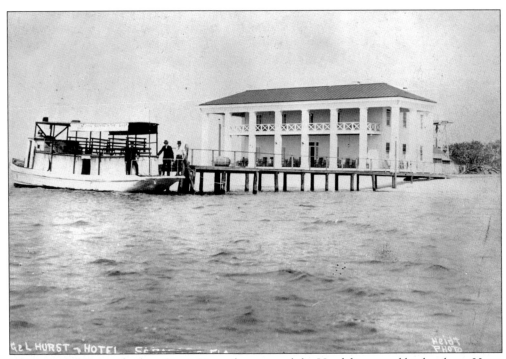

Before the bridge was built to Siesta Key, a ferry named the *Vandalia*, owned by developer Harry Higel, would transfer people to and from the island. The building in the background of this 1916 view is the Higlehurst Hotel, which burned down in 1917.

Prior to 1893 when the S.S. *Mistletoe* ran, the ship *Nemo* carried freight between Tampa and Sarasota. This view shows the bay front and city dock located at the base of Main Street.

Fishing docks were located along the bay front on lower Main Street. Cedar Point (Golden Gate Point) is seen in the background, c. 1895. By 1916 the pier housed several fish houses, machine shops, and a refining company. In 1921 a hurricane demolished the dock and destroyed the buildings located on the dock. It also destroyed the railroad tracks, which gave Sarasota the opportunity to move the unattractive fishing industry out of downtown. A 700-foot cement pier was built for recreational purposes. Philanthropist Calvin Payne provided money for dredging nearby and convinced the Seaboard Railroad to run the tracks to the new location. The terminal was named Payne Terminal after the generous winter resident.

The S.S. *Mistletoe* was the first ship to bring passengers and cargo from Tampa to Sarasota in 1895. A prominent businessman named John Savarese owned the vessel. Sarasota depended on the S.S. *Mistletoe* for transportation and ice. The ship was able to travel to Sarasota after two channels were cut into the area due to the River and Harbor Acts of 1890, 1892, and 1894. The channels were located at Longboat Key Pass in Sarasota Bay and at Palma Sola Pass in upper Sarasota Bay.

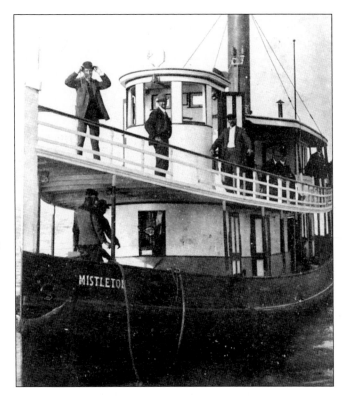

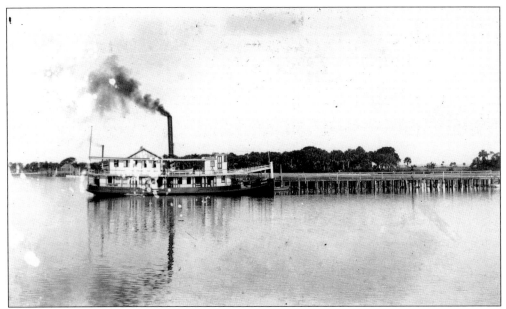

The S.S. *Mistletoe* is docked at the town dock, called Higel Dock, in 1895. Cedar Point, which is now referred to as Golden Gate Point, is seen behind the dock. The docks and fishing houses were later demolished during a hurricane in 1921.

Shown here is the first railroad being built to Sarasota Bay. From left to right on the bank are Bone Hogan, Frank Higel, Bill Jeffcott, and Frank Pinard.

The Seaboard Railroad dock extended from Strawberry Avenue. The United States and West Indies Railroad laid out the tracks shortly after they brought the tracks into Sarasota in 1903. Fish houses were built at the end of the dock and used to unload fish.

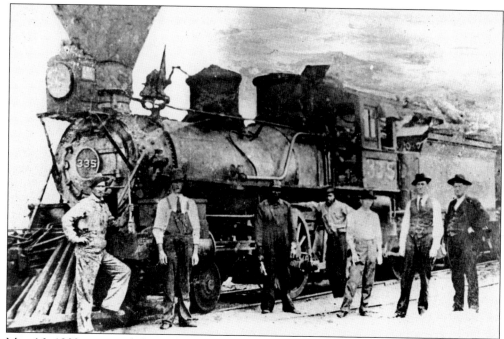

May 16, 1903 witnessed the arrival of the first train of the Seaboard Air Line Railway, a key event in the development of Sarasota. Although there had been a short lived rail service in the 1890s, called the "Slow and Wobbly," this new rail connection was permanent. The consent of Mrs. Potter Palmer for the railroad to pass through her extensive holdings was essential in the expansion of rail service to the area.

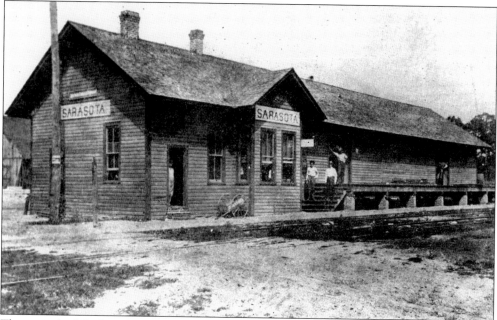

The arrival of Seaboard Air Line Railroad station in 1903 helped Sarasota progress. Roads were difficult to travel, and the train made it easier to get around and move supplies for building and development.

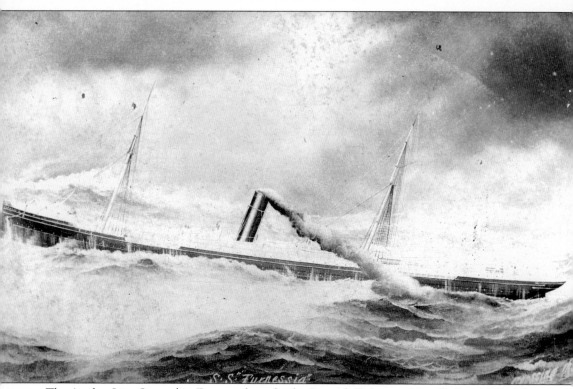

The Anchor Line Steamship *Furnessia* brought the Scottish Colony to New York in 1885. After traveling by train and boat, several settlers arrived in Sarasota in hopes of starting new lives. They had been told that Sarasota was a prosperous town and that housing and land were waiting for them when they arrived. Unfortunately, this was not the case, and, to make matters worse, they experienced a heavy frost and snow their first winter. Due to the lack of proper accommodations, many investors left.

Six

DEVELOPMENT

THE MAINLAND

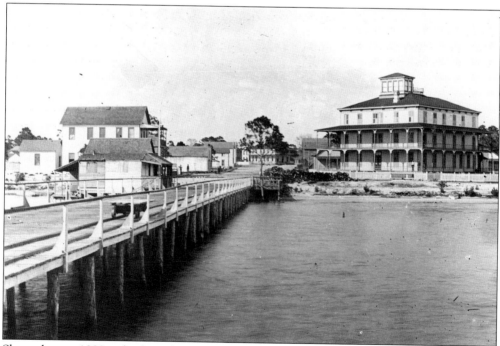

Shown here c. 1888 is the foot of Main Street on Sarasota Bay with a view of the De Soto Hotel on the right and the Vincent Brothers' Restaurant on the left.

The Florida Mortgage and Investment Company produced Sarasota's first town map in 1885. The map was recorded at the Manatee County Courthouse on July 27, 1886.

In 1885, First Street, located between Central and Pineapple, was a dirt road covered with buggy tracks.

Cattle roaming the streets in the 1890s used the Main Street water trough. The water came from an artesian well that was built for the De Soto Hotel. Pipes ran down Main Street to Palm Avenue.

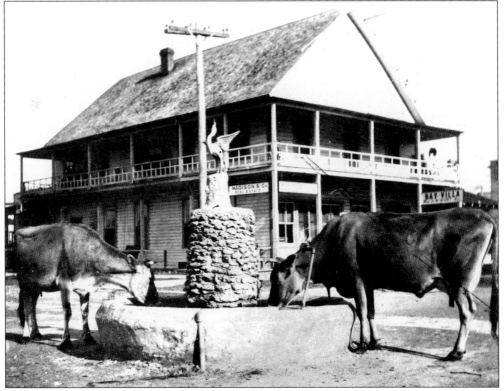

This picture of Victor Grantham was taken downtown at Five Points. Grantham ran errands for people in his cow-drawn cart. A glimpse can be seen of the *Sarasota Times* building, which housed Sarasota's first newspaper.

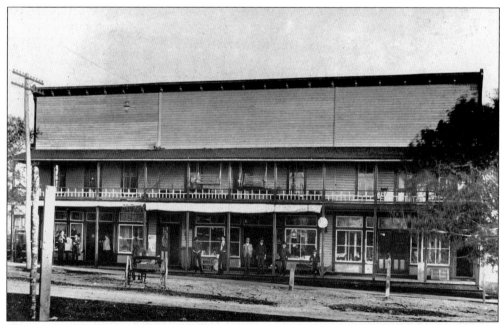

The General Store was owned by Highsmith, Turner, and Prime and was located on lower Main Street. The store provided the town with a little of everything needed. Cash wasn't the only payment. Sometimes people would trade produce, animals, and even alligator hides for merchandise.

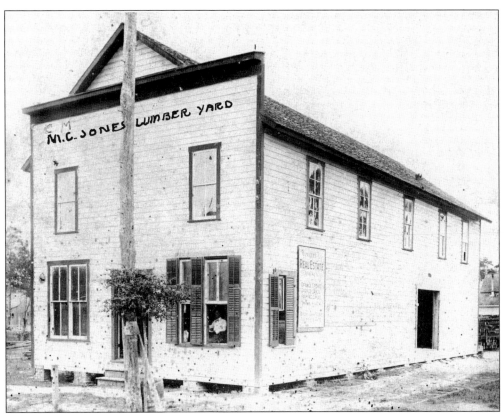

The M.C. Jones Lumberyard was located on the corner of Lemon and Main Streets.

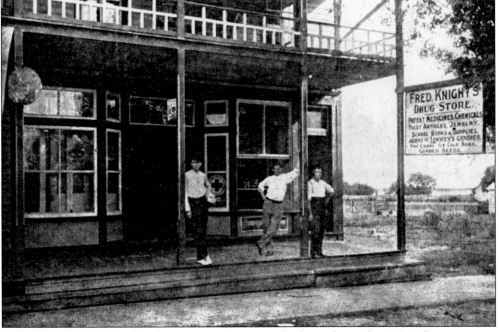

W.F. Knight owned the first drug store in Sarasota, which was located on Main Street.

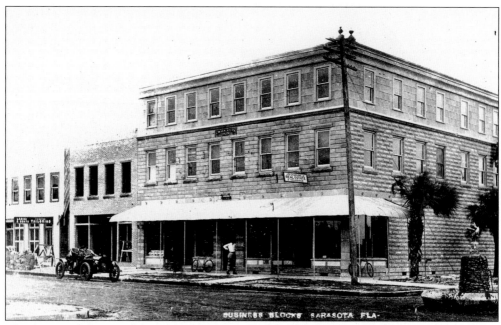

The downtown business block located on the corner of Main Street and Palm Avenue housed Blackburn's Hardware, J.B. Chaplines Real Estate, a tailor shop, and dentist S.S. Curry.

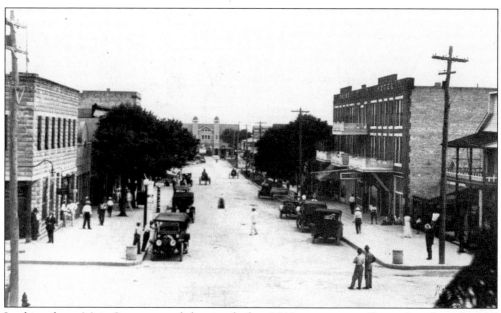

Looking down Main Street toward the city dock c. 1910, one can see Hover Arcade at the end of the street. Dr. W.E. Hover and his two younger brothers, J.O. and Frank B. Hover, bought the pier from Harry Higel, expanded the size, and constructed an arcade in 1913. The Hovers then sold the pier to the county to use as the courthouse.

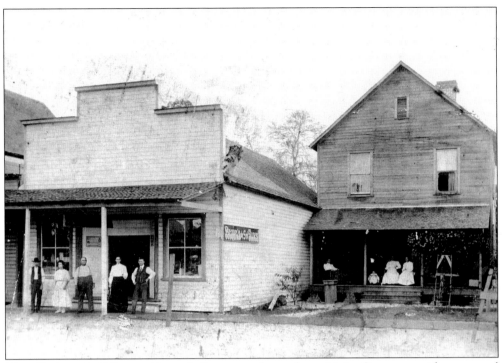

The Clark and Calhoun General Store was located on Main Street, providing general merchandise for the town's people. J.A. Clark opened his store in the early 1910s. He stocked dry goods and notions, as well as men's hats, shoes, and furnishings.

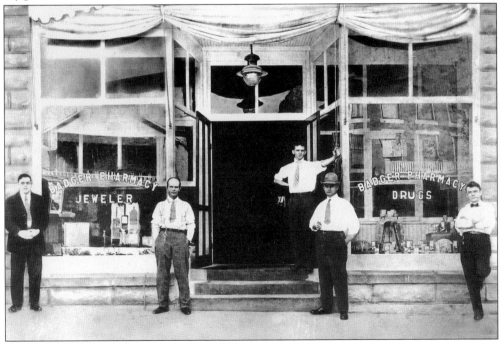

Shown here is the Badger Pharmacy c. 1905 located on Main Street. From left to right are Bill Edwards, Mack Christie, unidentified, and Jim Halton.

The City Livery Stables were located on the northeast corner of Main and Lemon, depicted in this 1907 photograph. Unfortunately, the stables burned down in 1908. The adjacent house belonged to Eliza Grantham.

For many years townspeople had to get water from wells and cisterns, so Sarasota built a water system to supply water shown here in 1910. Since there were also no sewers, a bond was issued in 1911, and by the end of the year, the business and residential area had water and sewers.

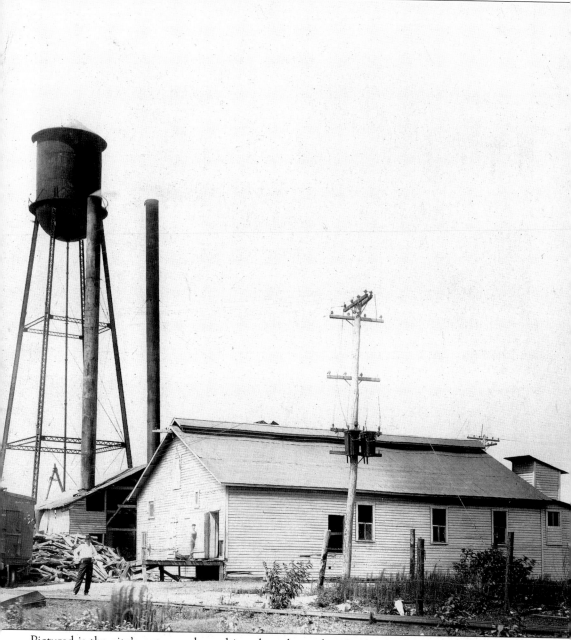

Pictured is the city's water works and ice plant, located on Lemon and Pineapple. When the city of Sarasota was incorporated in 1902, there was no water system. Sarasotans would get their water from wells or cisterns. In 1909, a bonded was successfully voted on to provide the town with money to drill an artesian well and for laying water and sewage pipes.

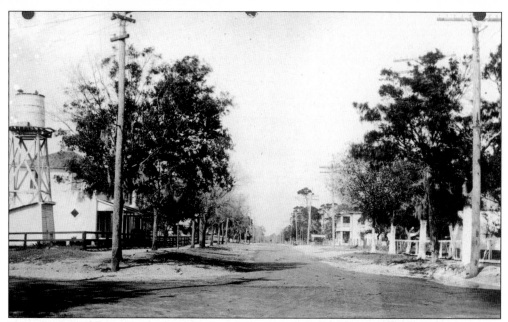

In 1905 Sarasota's Five Points was the home of some of J.H. Lord's rental properties. Lord, who purchased over 100,000 acres of land from Sarasota to Venice, owned the three houses on the left. For several years he was the largest property owner in the Sarasota Bay area.

Palm Avenue is one of the upscale streets in Sarasota today, filled with beautiful art galleries and boutiques. However, looking at this picture taken in the early 1900s, there wasn't much to see except for a beautiful tree-lined street.

The original dock was located downtown. It housed several buildings including John Savarese's fish houses located on the left, which were destroyed in 1921 by a large storm.

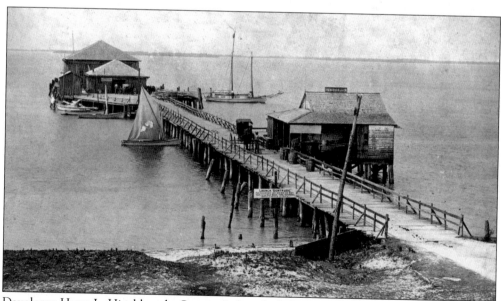

Developer Harry L. Higel bought Sarasota's first dock from Col. J.H. Gillespie. Located at the foot of Main Street, the dock was used for commercial purposes. The S.S. *Mistletoe* would make stops three times a week here. The sign advertises boat charters on The *Gertrude*. This image is from 1899.

This 1927 view shows the detailed entrance to the Sarasota County Courthouse.

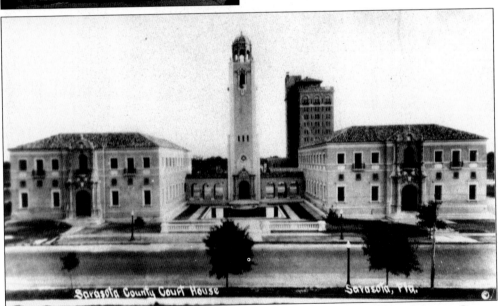

The Sarasota County Courthouse is located at 2000 Main Street. When Sarasota County separated from Manatee County in 1921, Sarasota needed a courthouse. Architect Dwight James Baum was hired to design the building. While the new courthouse was being built, a temporary courthouse was set up in the Arcade building located on the pier. The cornerstone was laid in May of 1926, and the building was completed in February of 1927.

94

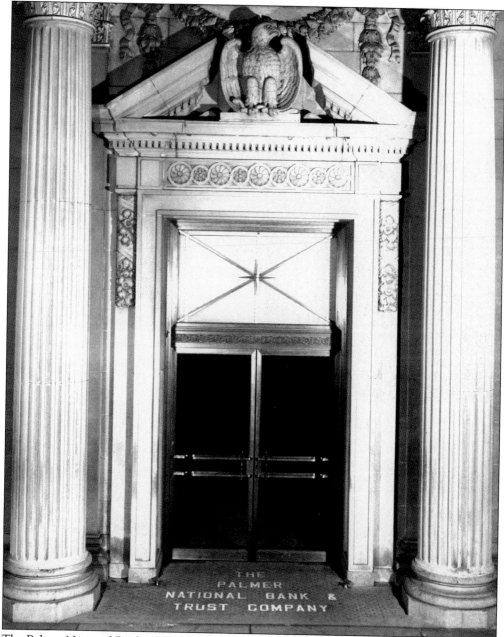

The Palmer National Bank and Trust Company opened July 20, 1929. Originally the First Bank and Trust, it was renamed by the Palmers when they took it over.

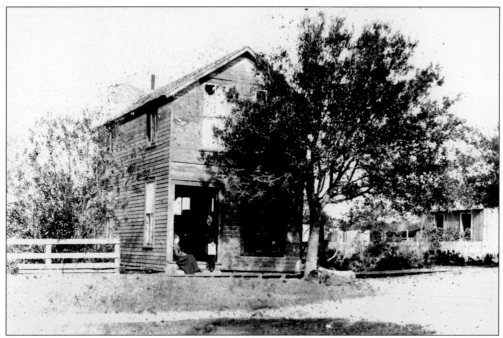

Shown *c.* 1900 is the *Sarasota Times* building. The paper was founded by owner Cornelius V.S. Wilson and his wife in 1899. Wilson was the publisher of the Manatee Advocate before coming to Sarasota and published the *Sarasota Times* until his death in 1910. His wife continued publishing the paper until 1923, when she sold it to J.H. Lord and T.J. Campbell.

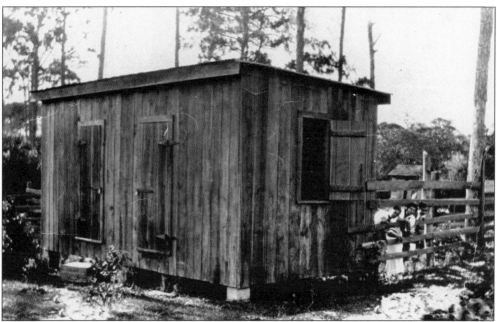

The Sarasota Jail, shown in 1911, was located on Eighth Street and Lemon Avenue. This small wooden building had few windows and was said to be unbearably hot in the summer months.

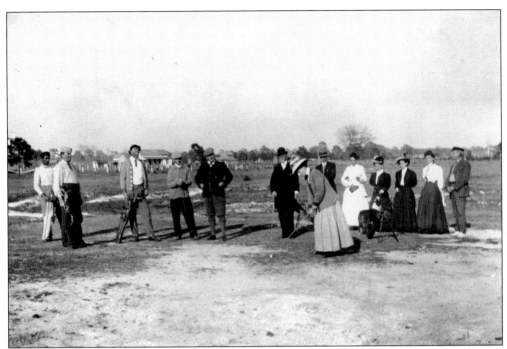

Col. J. Hamilton Gillespie built Sarasota's first golf course. The two-hole course was one of the first golf courses built in the country. A group is shown here golfing in 1886.

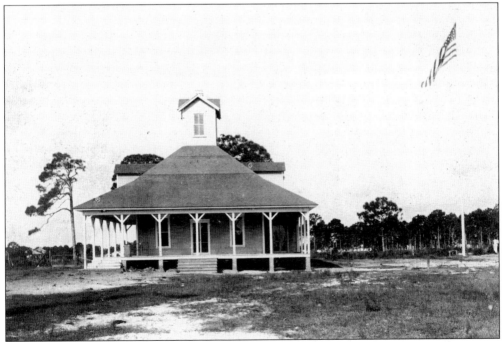

Col. J. Hamilton Gillespie built a clubhouse on his golf course in 1905. He was enthusiastic about the game of golf and wanted to expand his new golf course.

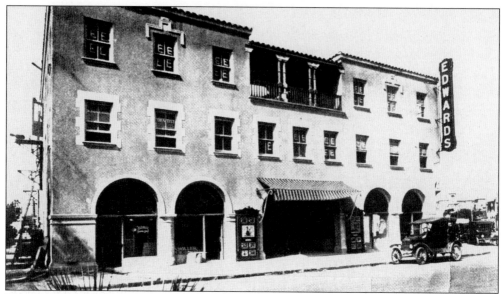

The Edwards Theater opened in 1926. A.B. Edwards opened and ran the theater for many years. The theater, which is located on North Pineapple, housed several entertainers, including humorist Will Rogers and the Chicago Grand Opera. Opening night they played the movie *Skinners Dress Suit*, which starred Reginald Denny and Laura La Plant and was accompanied by a New York organist.

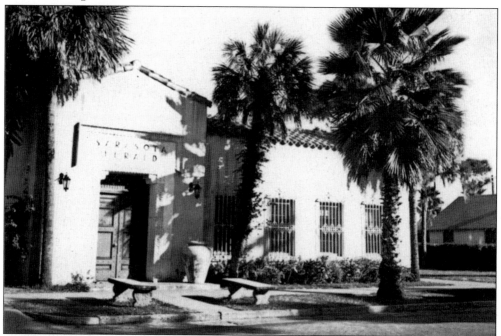

The *Sarasota Herald* first published its paper in 1925; the building is shown here c. 1935. Shortly after circulation began, the paper went from a weekly to a daily schedule. For over 20 years Editor George D. Lindsay led the paper; its mission was to be involved in the social, economical, and educational development of Sarasota. *The Herald* eventually grew out of the building at the corner of Orange and Oak Street. Today, it houses the Women's Exchange.

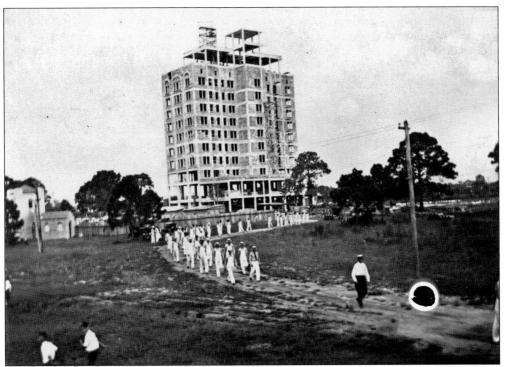

The Terrace Hotel, pictured in the 1920s, was built by Charles Ringling.

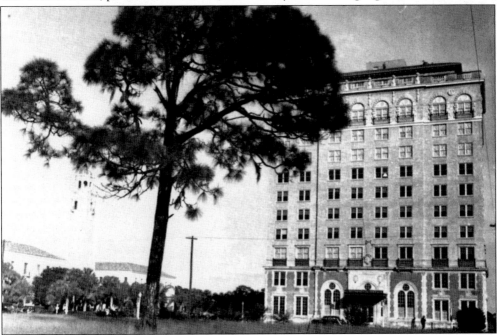

In 1925, Charles Ringling built the Terrace Hotel, today's county administration center. This was the first of many buildings in a series that would make Ringling's Courthouse Subdivision. Charles, a personable man who cared about Sarasota, was involved in community affairs. He served two years as president of the chamber of commerce from 1924 until 1926, when he died.

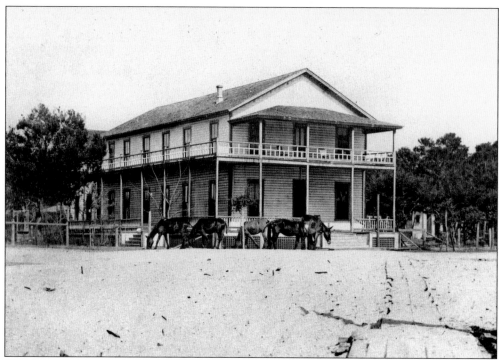

The Sarasota House, shown in the 1890s, was built on Main Street in 1886 to be used as a rooming house by FM&I, the Scottish Investment Company. The property changed hands, and J.H. Lord, a large developer, purchased the property. Eventually, the Sarasota House was torn down to make room for the First Bank and Trust Company in 1924.

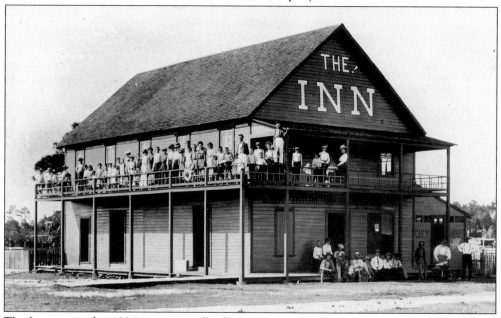

The Inn, pictured *c.* 1894, was originally the Livery Stables of Whitaker and Smith. A Baptist group took over the Inn for a spiritual convention and vacation spot, thus creating Sarasota's first convention hall.

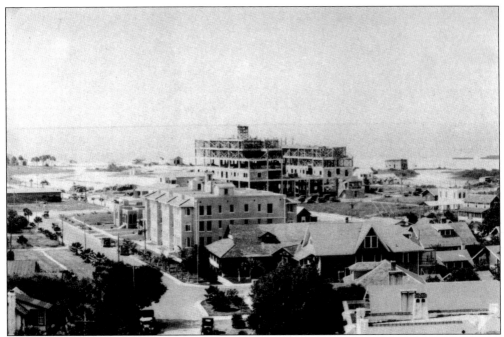

This panoramic view shows The El Vernona Hotel under construction in 1925. Architect Dwight James Baum designed the hotel.

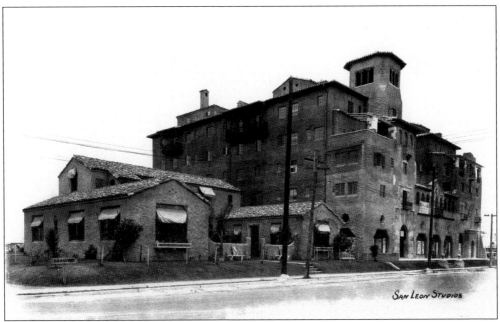

Owen Burns built the El Vernona Hotel in 1926 and named it after his wife Vernona. This 150-room hotel was designed by architect Dwight James Baum and was thought of as one of the finest resort hotels. In 1930 the ownership changed hands to John Ringling, who renamed the hotel the John Ringling Towers.

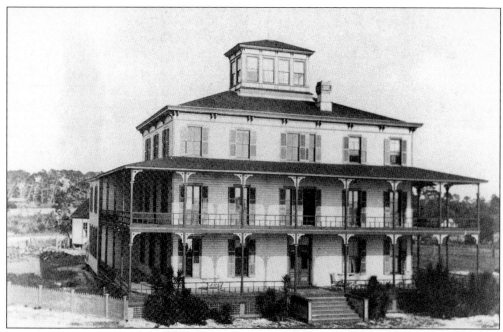

The De Soto Hotel, featuring 30 large rooms, was built by Colonel Gillespie in 1886. It also featured a large lobby and a dining room.

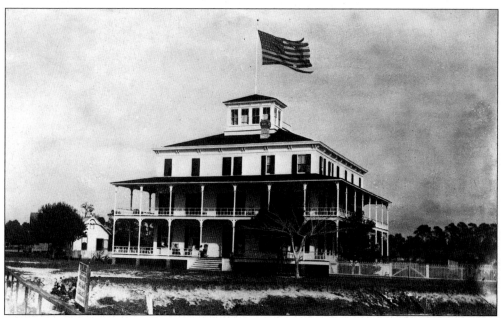

The Belle Haven Inn, pictured c. 1887, was originally called the De Soto. J.H. Gillespie built the hotel and marketed it to the wealthy.

THE BELLE HAVEN INN

SARASOTA. FLORIDA

Has been thoroughly renovated and is under new management. Large, airy rooms, single or en suite, with or without fire, and private sulphur baths. Large spacious verandas, overlooking beautiful Sarasota Bay. Is situated immediately on the bay shore, and is in sight of the rolling Gulf of Mexico. Large pretty lawns and pretty park. Tennis and croquet, also free row boats for the guest. Fishing, boating and bathing the best, hunting good. House open all the year round.

Rates by the day $2.50 to $3.50. Special rates by the week and for families. For further information apply to **H. S. SMITH, Proprietor**

The Belle Haven Inn advertised to people near and far. This advertisement claims Hamden S. Smith as the new manager in 1908. The hotel advertised recent renovations, large airy rooms, balconies overlooking Sarasota Bay, and private baths.

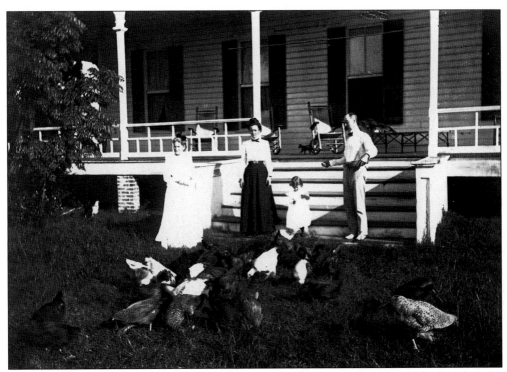

Visitors at the Belle Haven Inn enjoy feeding the chickens from the steps of the hotel in the 1890s. Prior to 1912, chickens, cows, and other animals could roam the town.

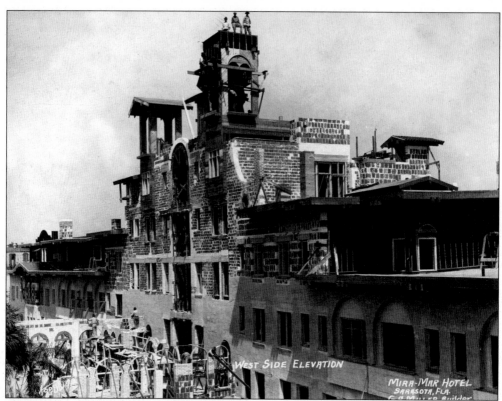

The Mira Mar Hotel at 37–85 South Palm Avenue was under construction in this picture.

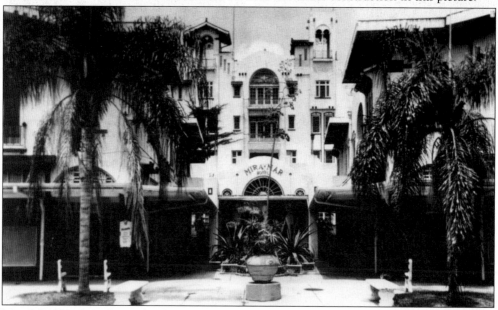

Mira Mar Hotel was located at 37–85 South Palm Avenue. Andrew McAnsh came to Sarasota in 1910 to invest in real estate. He built a hotel, an auditorium, and an apartment complex downtown. McAnsh negotiated with the town and was provided with free light, water, and no taxes against the building for 10 years.

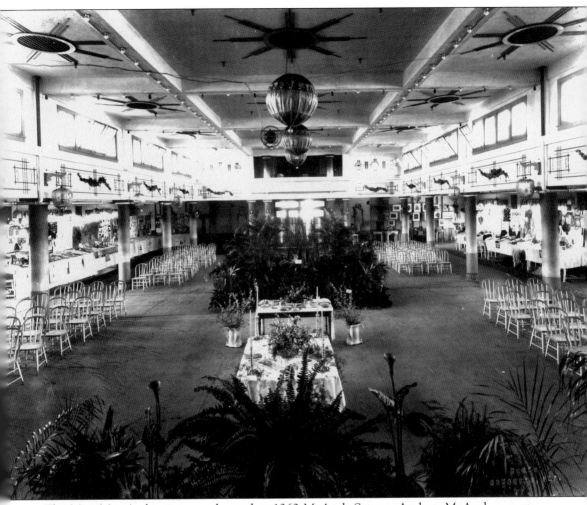

The Mira Mar Auditorium was located at 1360 McAnsh Square. Andrew McAnsh came to Sarasota from Chicago in hopes of building a hotel, apartment buildings, and an auditorium. He negotiated with the town to get free light and water and to operate without taxes for 10 years. He purchased several large lots on Palm Avenue and built the complex. The apartment complex was built in 60 days, and the hotel and auditorium in 6 months.

Pictured here is a 1903 tax receipt, one of Sarasota's first, belonging to Harry L. Higel. When the town became incorporated in 1902, Sarasota started taxing residents for town improvements.

Council president Hugh K. Browning lived downtown on Gulf Stream Avenue next to the Belle Haven Inn.

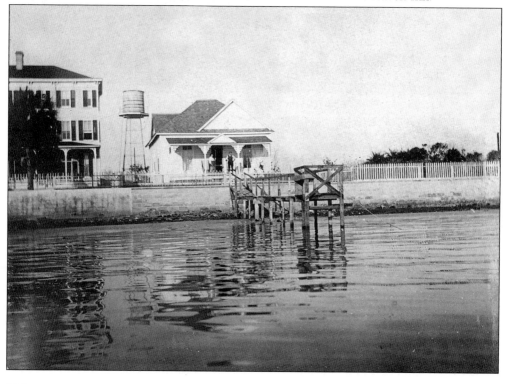

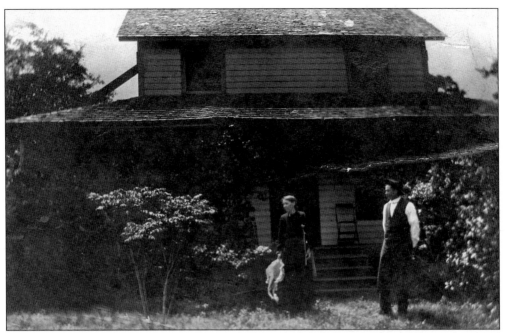

Peter and Sophia Crocker lived near Bee Ridge Road. Peter was a Civil War veteran and postmaster in Crocker. Before moving to Bee Ridge, he lived in a lean-to on the bay. Mrs. Crocker had the area's first Singer sewing machine, which impressed many Sarasotans.

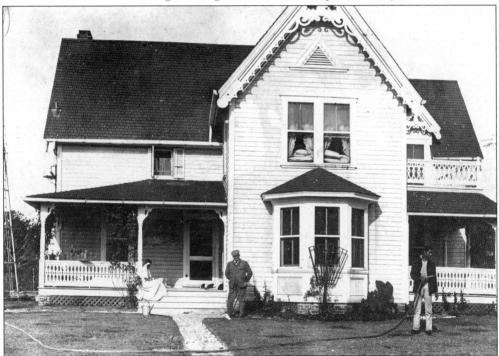

Roseburn was the Morrill Street home of Col. J. Hamilton Gillespie. The home is now a part of Prew School. Pictured c. 1906 in the yard from left to right are Mrs. Blanche Gillespie (Colonel Gillespie's second wife), Colonel Gillespie, and Leonard Reid.

Owen Burns built Burns Court in the 1900s. The small houses were less than 1,000 square feet. Intended for starter homes, these quaint properties were located downtown. Shown here is Burns Court under construction in 1924. The sub-division included 15 homes and 9 shared garages. These attractive and small units were designed to let the breeze blow through by placing windows on all four sides of the house. The houses were designed by the architect Thomas Reed Martin.

The houses in Burns Court were of Spanish design. Each house was unique. This picture shows two of the houses—number 416 and number 110 are on the north side (right side of picture.)

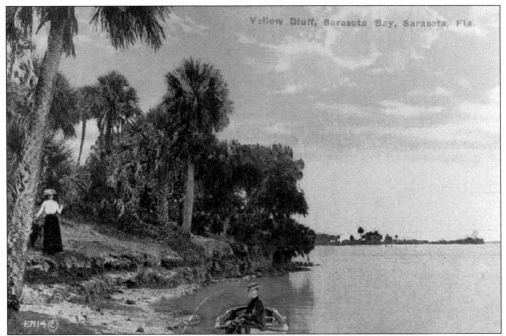

Yellow Bluffs was named for the nearby outcropping of yellow limestone. First pre-historic and Calusa Indians lived here, and then William Whitaker built on Yellow Bluffs in the 1840s. Today, Yellow Bluffs is located at the corner of Twelfth Street and the Tamiami Trail. Yellow Bluffs is also noted for being the place where the Confederate cabinet member Judith P. Benjamin fled from America to the Bahamas at the end of the War Between the States in 1865.

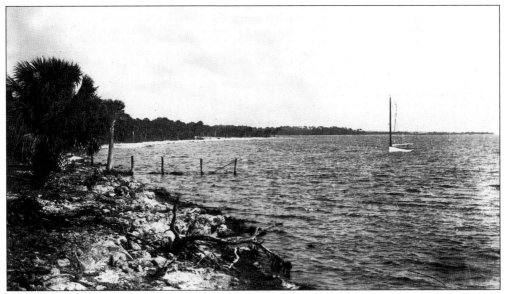

Indian Beach is located north of Whitaker Bayou on Sarasota Bay. The Indian Beach Land Company advertised the area in the 1910s, describing the area as the prettiest lots available on the entire bay. People who purchased the lots would be neighbors of prominent people such as the Ringling Brothers.

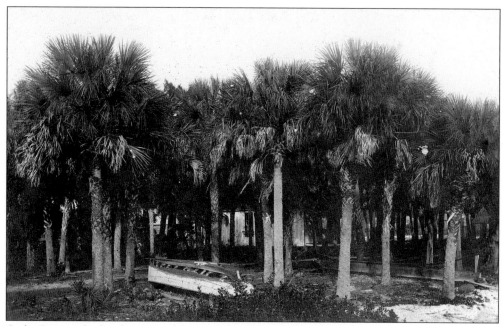

Cedar Point, which is known today as Golden Gate Point, was undeveloped in the early 1900s.

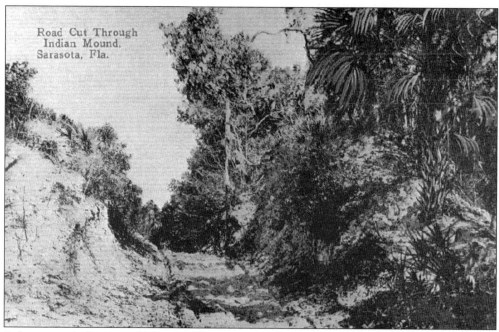

Road Cut Through
Indian Mound,
Sarasota, Fla.

Indian mounds, known as Indian Middens, were once found all over the region. However, many people robbed the graves or demolished them during development. This image shows a road cut through an Indian mound. Historic Spanish Point still boasts

Seven

DEVELOPING THE KEYS

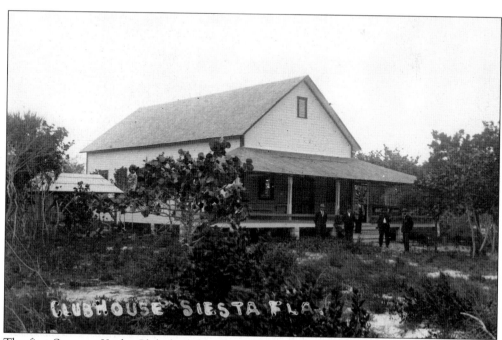

The first Sarasota Yacht Club, built by Harry Higel in 1907, was located at the north end of Siesta Key. This was part of his plans for the development of the north end of the key. He built a real estate office and applied for a post office for the island.

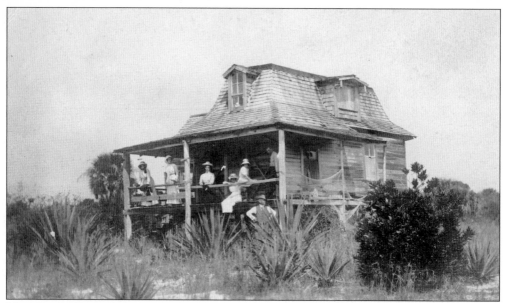

This Siesta Key cottage was owned by Sophie and Peter Crocker. Peter Crocker was the Postmaster for the Crocker Post Office and a Civil War veteran

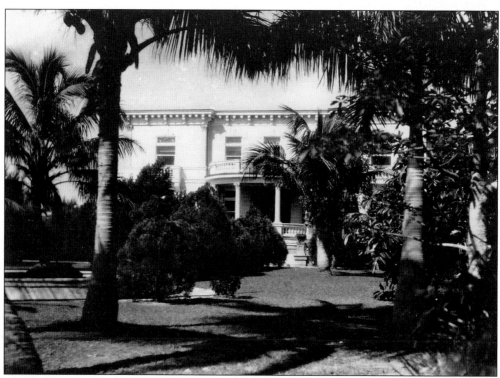

This Bird Key mansion was called the New Edzell Castle was built by Thomas M. Worcester of Cincinnati in 1914. John Ringling bought the island and castle and his sister Ida Ringling North lived their until her death in 1950. When the property was sold it was torn down for development.

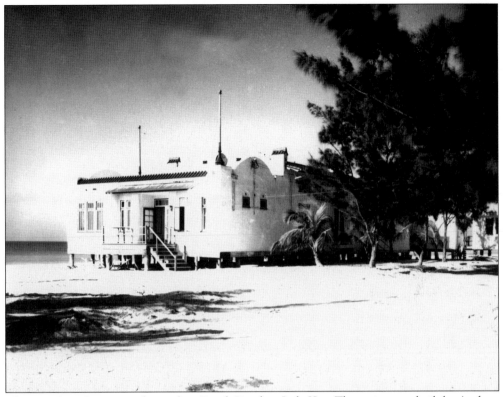

The Mira Mar Casino was located on Beach Road on Lido Key. The casino was built by Andrew McAnsh in 1925. He built a Mediterranean style casino, which included a lounge, dance floor, pirate clubrooms, and a dressing area for bathers.

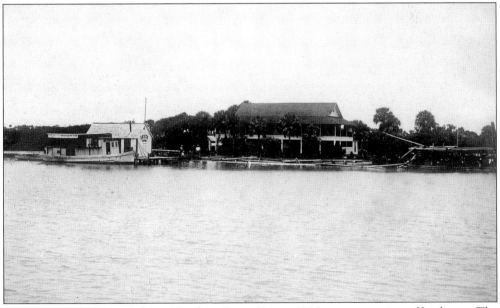

Louis Roberts built the Roberts Hotel on Siesta Key in 1906 as an extension of his house. The hotel, shown in this c. 1915 photo, had a good reputation for its clam chowder and scenic views.

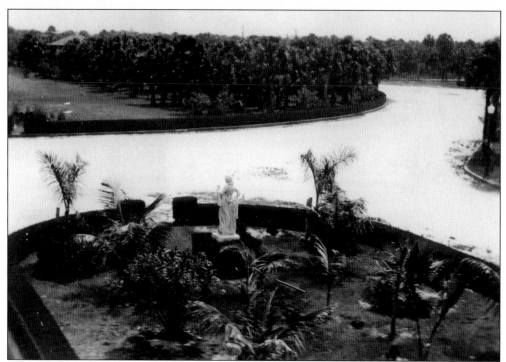

In the 1920s John Ringling purchased several acres on Lido, St. Armands, and Longboat Keys. With Owen Burns as his partner, Ringling developed these islands, calling the development Ringling Isles. This 1920s picture shows Ringling Isles under construction.

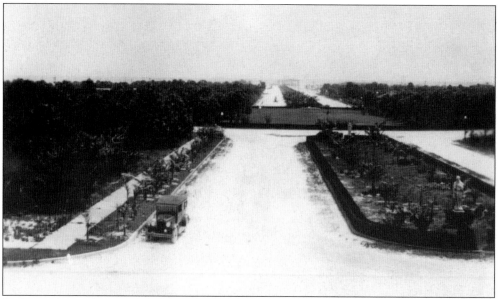

St Armands was the central feature of Ringling Isles. A causeway was built to lead people to the circle, and exits were provided to Lido Beach or Longboat Key. Ringling had some Venetian statuary delivered to the circle in order to dress up the area, with hopes of impressing such prominent people as President Harding. He even wanted to build a winter White House as part of his development.

Eight
RINGLINGS

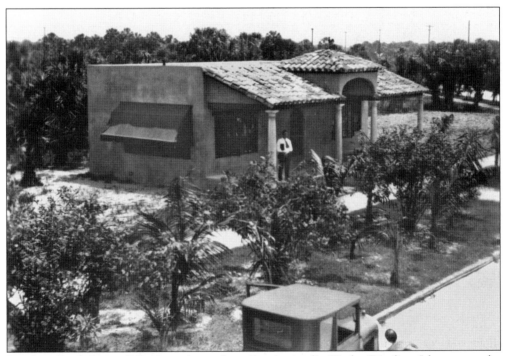

Ringling Real Estate Office was located on St. Armand's Circle. Ringling Isles was under construction in the 1920s. John Ringling developed some of the islands in Sarasota bay in partnership with Owen Burns.

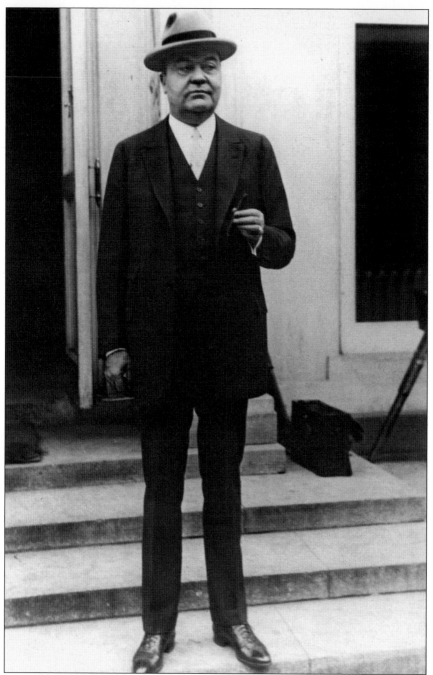

John Ringling helped promote Sarasota in many ways. He and his partner, Owen Burns, planned and built Ringling Isles, which included St Armands Key, Bird Key, Coon Key, and 2,000 acres on Longboat Key. He built the Ringling Causeway and bridge, so that people could travel to his developments. He built the Lido casino in 1926. When Ringling chose Sarasota as his winter quarters for the Ringling Brothers and Barnum and Bailey Circus, he advertised across the country about his new home. One of his dreams was to build a 200-room Ritz-Carlton Hotel on Longboat Key. Sadly it was never finished.

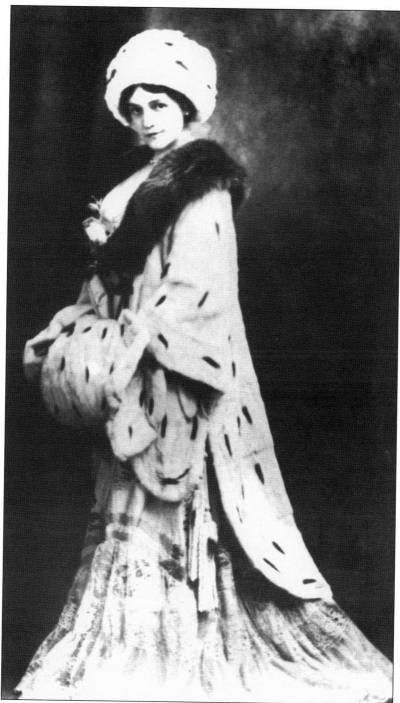

Mable Ringling was married to a prominent man and dressed the part. She participated in the Women's Club, the Garden Club, and the Whitfield Estates Country Club. Mable loved to collect art while travelling in Europe with her husband John. She wanted to have a home built in Sarasota that would resemble the style of the Doge's Palace in Italy. Eventually her plans became a reality and Ca d'Zan was built. She and John also built a museum to house their art.

John Ringling is pictured in the 1920s with Capt. Arthur Jackson Rowe on their trip to Cape Coral, where they gathered coconuts to sprout palms for the Ringling Isles Development.

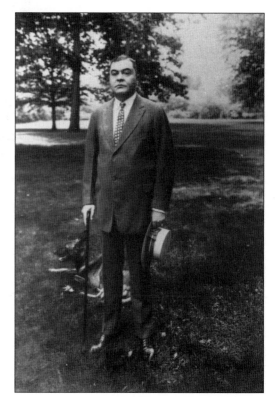

John Ringling was a businessman, a promoter, and a benefactor when he lived in Sarasota. He donated 130 acres of land on Longboat Key for a golf course and the Ringling Causeway and Bridge to Sarasota.

Mable Ringling is pictured with one of her four miniature Dobermans in 1926.

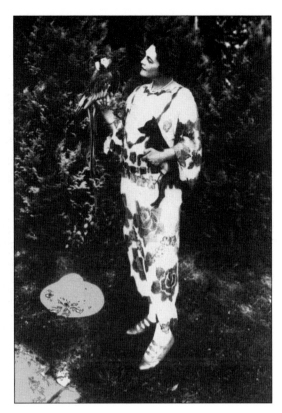

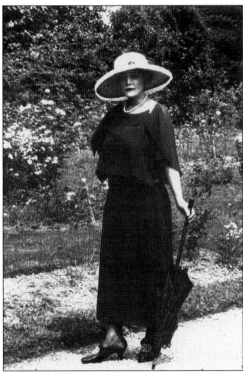

Mable Burton Ringling is shown at their Alpine, New Jersey estate.

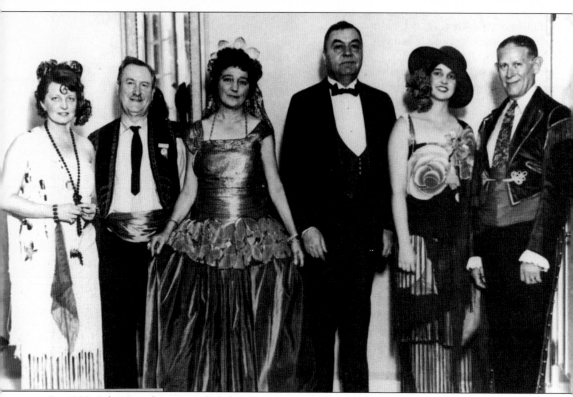

In 1928, John Ringling attended the Coronation Ball, which was held during the yearly Sara de Soto Pageant. Pictured from left to right are Mrs. Frances Booth, J.W. Burns, Mrs. A.E. Cummer, John Ringling, Frances Edwards (chosen queen that year), and Samuel Gupertz.

The late John Ringling left his dream house Ca d'Zan to Sarasota in 1946. Dwight James Baum designed the Italian Renaissance style palace and Own Burns was the builder. John and Mable decorated their house with antiques purchased at auctions in New York, Venice, and Rome. They used the colors red and gold as a theme for the interior. John liked European furniture from the 17th and 18th centuries.

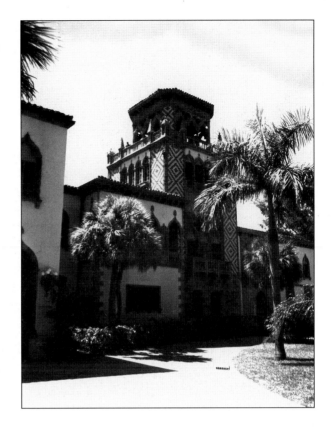

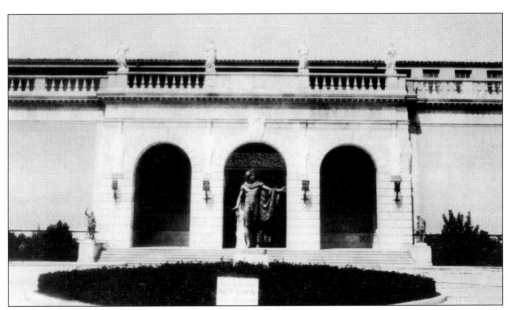

The Ringling Art Museum was also given to Sarasota in 1946. It is located at 5401 Bayshore Drive in Sarasota, next to the Ringling mansion, Ca d'Zan.

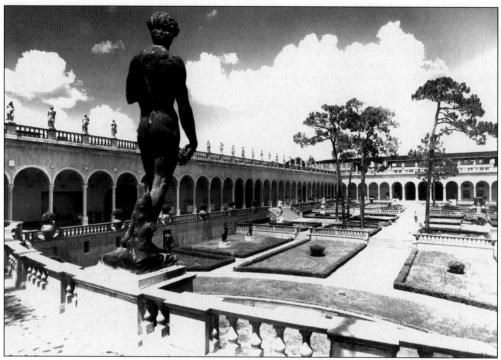

The courtyard of the John and Mable Ringling Museum is pictured in the 1930s. At the foot of the picture is one of the few bronze castings of Michelangelo's *David*. The Ringlings wanted a museum to store their artwork, which they had acquired all over Europe, so they hired John H. Phillips, one of the architects that designed the Metropolitan Museum of Art in New York City, to design their private gallery. It was later donated to the state of Florida.

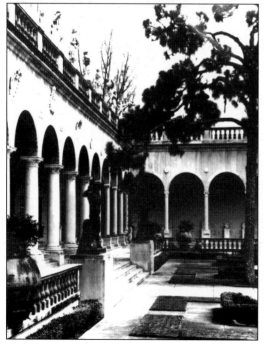

The Ringling Museum Court Yard houses several statues and columns from around the world. The Ringlings had building materials from all over the world shipped to Sarasota, including columns from Greece; statues, archways, and doorways from various European locations, and foundations from Italy.

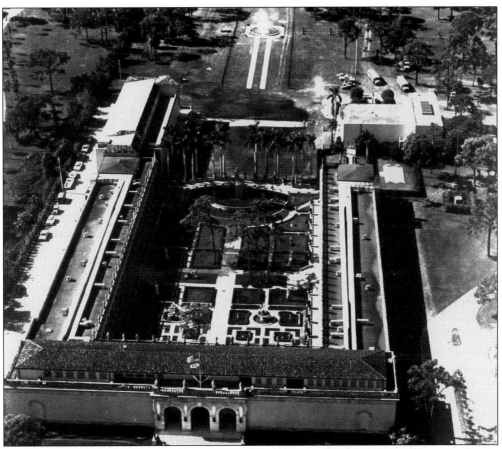

The John and Ringling Museum is seen in this aerial view. The museum, which is located on several acres on Sarasota Bay, and the art inside is worth millions. The Ringling Museum is noted for the large Ruben paintings, four in all.

The Bay Haven Inn, built by J.G. Whitfield, was a 70 room, three-story hotel that contained private baths and steam heat. It was located at the intersection of Indian Beach and Bradenton Roads. John Ringling purchased the property for his Ringling School of Art and Design. 1932

Entertainers performing an aerial act above the guests at the John Ringling Towers in the late 1930s. John North, John Ringling's nephew, incorporated a circus theme when he ran the hotel.

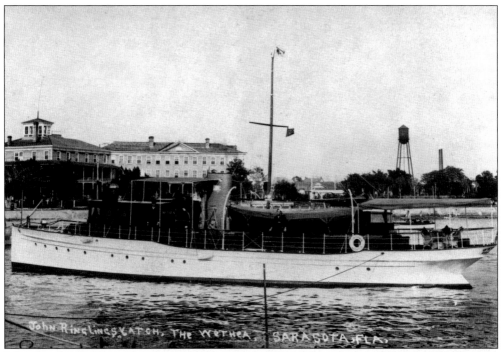

John Ringling's first yacht, captained by Arthur Jackson Rowe, was called the *Wethea*. The name was pronounced "wa-thee-a," which means "peace" or "peace pipe." If a blue flag was hanging it meant that Ringling was not aboard.

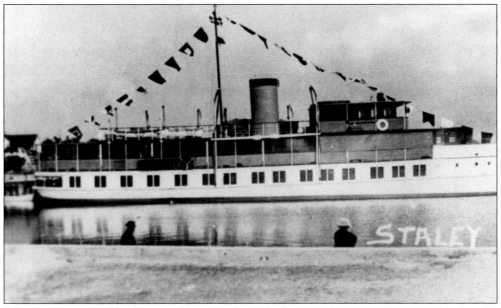

John Ringling's third yacht was called *Zalophus*, which means "sea lion." Ringling later bought *Zalophus II*. Built in Staten Island at a cost of $200,000, it met an untimely end on February 4, 1930, when an associate of Ringling borrowed the yacht, hitting a submerged object off Lido Key in the middle of the night. Ringling was in New York at the time, but people aboard included New York mayor Jimmy Walker and actress Betty Compton.

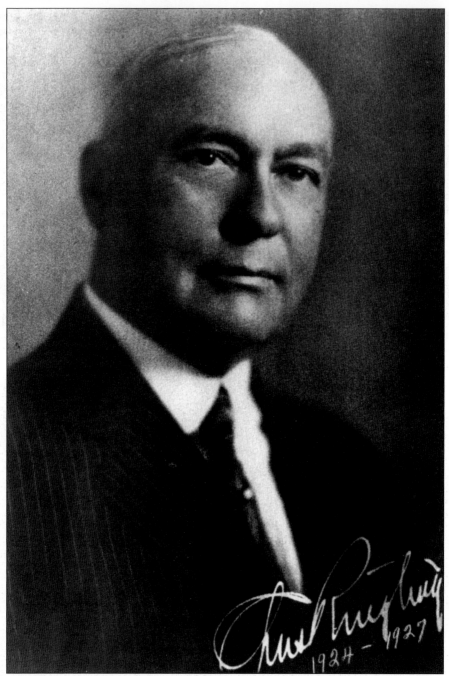

Charles Ringling, brother and business partner to John in the circus business, also settled on the Sarasota bay front, just north of Ca d'Zan. Charles was more philanthropic during his time in Sarasota, donating land for the courthouse. He was also a developer and hotelier, and he owned a 33,000-acre ranch. He was the founder of the Ringling Bank and Trust Co. and was president of Sarasota's chamber of commerce when he died in 1926.